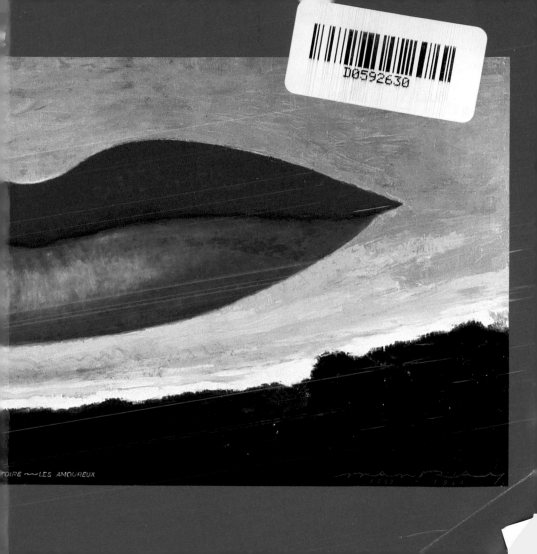

TOIRE ～ LES AMOUREUX

THE ESSENTIAL™

Man Ray

BY INGRID SCHAFFNER

THE WONDERLAND
PRESS

Harry N. Abrams, Inc., Publishers

THE WONDERLAND PRESS

The Essential™ is a trademark
of The Wonderland Press, New York
The Essential™ series has been created by The Wonderland Press

Series Producer: John Campbell
Series Editor: Harriet Whelchel
Series Design: The Wonderland Press/Marc van Schendel

Library of Congress Control Number: 2001133133
ISBN 0–8109–5831–7

On the end pages: Man Ray. *The Lovers* ("A l'Heure de l'Observatoire—Les Amoureux," with
Lee Miller's lips) 1934. Oil on canvas. 39 x 98" (100 x 250 cm). Stavros Niarchos Collection

Printed and bound in China

PHOTOGRAPH CREDITS:
Unless otherwise noted, all images are courtesy of Telimage, Paris
Courtesy Christie's Images: pages 36 (center photo), 105 (chess set)
Courtesy Art Resource, NY: pages 26 (both images), 28 (*Bicycle Wheel*)

Harry N. Abrams, Inc.
100 Fifth Avenue
New York, NY 10011
www.abramsbooks.com

Abrams is a subsidiary of

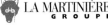
LA MARTINIÈRE
GROUPE

Contents

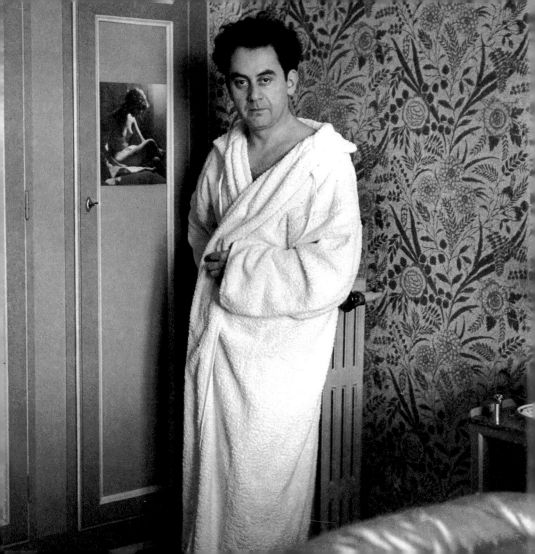

What's in a Name?

Man Ray was not his real name. He was born Emmanuel Radnitzky (sometimes it is spelled *Rudnitsky*). So why didn't he change it to Manny Radnitz? Or Nitzky? Because those names come loaded with family and history. And Man Ray, who wouldn't divulge when he was born or talk about his Brooklyn childhood, was practically allergic to history. For him, life and art meant the chance to create something new. He invented his new name by streamlining the old one down to its snappiest particles:

OPPOSITE
Self-Portrait in a Hotel Room
c. 1948

- **Man:** physical, primal, male

- **Ray:** technological, futuristic, light

Fused together, the names sound less like a person than a product line. *And in a way, Man Ray was a product line!* He was hugely enterprising. His industry included virtually every known artistic medium, from

Sound Byte:

> *My first name is Emmanuel. I changed it to Man,*
> *and my surname is nobody's business.*

—MAN RAY, 1958

5

sculpture to film. He ran successful enterprises in art, studio portraiture, and fashion photography. He went international, working in New York, Paris, and Hollywood. He counted among his friends and contacts the most fascinating individuals of the day, from the author Ernest Hemingway to the actress Ava Gardner. And though he preferred to be known as a painter, today he is recognized as **one of the most brilliant photographers ever to click a camera.**

Sound Byte:

> *To most, Man Ray was a mystery.*
> —MERRY FORESTA, art historian
> *Perpetual Motif: The Art of Man Ray*, 1988

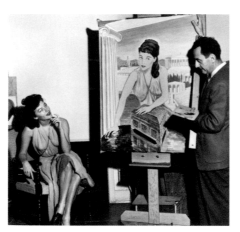

NEAR RIGHT
American actress Ava Gardner poses for a painting by Man Ray that later appears in the movie *Pandora* 1950

RIGHT
Ernest Hemingway 1922. Photograph

Inventing the Surreal

Besides having invented his name, the American artist **Man Ray** (1890–1976) also invented some of the most surreal images of the 20th century:

- a giant pair of disembodied lips that sail across a stormy sky, rolling the entire length of a painting that measures eight feet wide;

- real nails or thumbtacks that sprout from the flat side of an old iron;

- a photograph that shows a woman's cheek glistening with glass tears, her eyes rolled back in ecstasy, her eyelashes made plastic with mascara.

The combinations are simple—lips and sky, for example—yet strange and bewitching. And no matter how many times you see them, these pictures manage to disturb and arouse. Man Ray knew how to create **mystery** and **provocation**. *It's as if he had a secret scope that enabled him to probe our most intimate fears and desires, which he then projected for all to see and share.* In many respects, Man Ray's art was about inventing ways of *liberating the imagination* as efficiently as possible.

FYI: The name game—Friends called him **Man**. But to the rest of us, he's **Man Ray**. (Calling him "Ray" would sound a bit ridiculous.) So how to alphabetize? If you look under "M," he's probably under "R"—and vice versa.

Machine-age man of mystery

After all, it was the Machine Age in which Man Ray lived. *Why waste time laboring over fusty techniques and traditions when you can just pick up, say, a camera?* Man Ray frequently did just that. Besides being a photographer, he was also a painter, sculptor, object maker, illustrator, filmmaker, printer, philosopher, and poet. (*Words can be used to create pictures, too.*) He employed whichever medium best suited the picture he had in mind. His goal was to be as direct as possible, and you'll notice that some of his paintings have more in common with illustrations than with traditional works of oil on canvas.

Curiously, this mechanical approach to picture making is one of the most powerful sources of mystery in his art. *How so?* Because it makes it seem as if those objects and images were not so much created as found—like appliances, clouds, or evidence. *Really, darling, I didn't see that the iron had sprouted nails and now my Chanel shirt is in shreds.*

I swear, officer, I looked up at the sky and these lips were smiling all sexy at me. That's why I lost control and drove into the duck pond. You want more proof? Okay, here in the photograph: The lady was crying glass tears, I tell you.

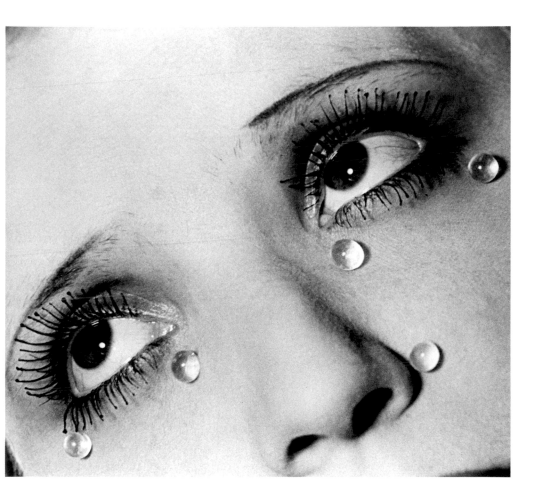

From Manny to Man-hood: 1890–1912

And so the story begins: Man Ray was born Emmanuel Radnitzky on August 27, 1890, in Philadelphia, Pennsylvania. During his childhood, his parents—Jewish emigrants from Russia—worked their way from laborers in the garment industry to owners of a tailoring shop. The shop where the whole family labored was in the Williamsburg section of Brooklyn, New York, to which they moved when Emmanuel was seven. The oldest of four children, Emmanuel showed signs of becoming not an artist in the conventional sense of expressing an early talent for painting and sculpting, but a precocious artist of **illustration and invention:**

- His drawing of the U.S. battleship *Maine* blowing up in Havana Harbor in 1898 is **faithful** and **fantastic**: a good copy of a black-and-white newspaper image that explodes with every color of the rainbow.

- His design for a brass lampshade perforated with little holes is an ingenious replacement for the family's tattered paper one. Too bad it cost the destruction of mom's sewing machine. (Shades of sculptures to come!)

At school, he fared poorly in most academic subjects—save English—but excelled in a curriculum of technical drawing and lettering. He illustrated his class-of-1908 Boy's High yearbook. When he won a

scholarship to study architecture at New York University, he seemed to secure his future. The only problem was that Emmanuel had aquired (from his working-class, immigrant family) an unfortunate interest in art. He turned down the scholarship and set out to learn the fundamentals of painting.

Prodigal Black Sheep: 1908–12

Ever resourceful, Emmanuel cobbled together an unconventional education in art. He attended art classes at various academies, then settled in at the bohemian alternative: the **Francisco Ferrer Social Center.** There, he studied with **Robert Henri** (1865–1929) and **George Bellows** (1882–1925), both of whom were representatives of the **Ashcan School** of painting. (He was deeply impressed by his female colleagues' willingness to strip and model during drawing class.) He visited museums to learn about the old masters and went to galleries to see what was new. In the spring of 1911, he found himself at **Gallery 291** (named for its Fifth Avenue address), where he met the gallery director, **Alfred Stieglitz** (1864–1946). Impressed by the young man's enthusiasm for Modern art, the celebrated photographer promptly invited Man Ray to join him at the regular luncheons he held at a local restaurant, attended by rapt listeners.

Of the many shows he saw at Stieglitz's, four in particular impressed Man Ray—and influenced his own art:

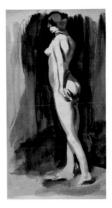

Nude Woman Standing. 1912
Ink drawing

BACKTRACK
MAN RAY'S
NEW YORK EDUCATION

Man Ray began attending lectures and art classes in the fall of 1912 at the **Francisco Ferrer Social Center**, or **Modern School**, located in Harlem. The center was founded by the anarchist **Emma Goldman** (1869–1940) and attracted radicals and free spirits like Man Ray. It was named in commemoration of a teacher who was assassinated in Spain for his progressive politics.

The Ashcan School was considered to be the first truly American school of painting. Its artists wanted to show the gritty reality of modern urban life: tenements, street urchins, and boxing rings—favorite *(continued on opposite page)*

Portrait of Alfred Stieglitz
1913. Oil on canvas

■ **Watercolors by the French sculptor Auguste Rodin** (1840–1917): Each nude study was composed rapidly, while the models moved around the studio under the artist's direction. The watercolors may not be anatomically correct, but they are erotically right-on. *See the sex sparks in Man Ray's own future nudes.*

- **Watercolors by the French painter Paul Cézanne** (1839–1906): Whenever you see faceted planes or surfaces, think Cézanne. His use of paint to give substance to light and our perception of it underlies all of early **Modernism**. *See the Cubism in Man Ray's early abstract paintings. But, more interestingly, see how he makes **light** a "thing" in his experimental photography.*

- **Sculpture by Constantin Brancusi** (1876–1957): The Romanian-born artist was perhaps the most important sculptor of early Modernism. His respect for materials, superb craftsmanship, and unique vision combined to produce geometric works of extreme simplicity in which an organic object appeared reduced to its essence in stone or metal. *Man Ray actually met Brancusi in Paris; their friendship was profoundly important for both.*

- **African masks:** In their search for alternatives to high-art traditions, Modernists looked to tribal art, in which they saw simpler means of representation, potentially new forms of abstraction, and/or just plain magic. *See **Noire et Blanche** (on page 67), a photograph in which Man Ray uses an African mask as a prop.*

BACKTRACK, continued...

subjects of the artist **George Bellows** (1882–1925). The group came into being when the painter **Robert Henri** (1865–1929), who donated his services to the Ferrer Center, withdrew his work from an important New York exhibition after paintings by some of his friends had been rejected. In retaliation for this rejection, the group organized an independent exhibition at the Macbeth Gallery in February 1908 to show the contemporary art in which they believed. Man Ray attended this exhibition and was no doubt influenced by the painters' passionate commitment to artistic freedom, if not by their gritty style of realistic painting. Henri crusaded to bring art to everyday people; he taught students at the Ferrer Center to follow their instincts (and not bow to tradition), and to cherish the ideas—not the techniques—that inspired their art.

BACKTRACK
ALFRED STIEGLITZ

One of the most essential figures in American art history, Stieglitz was:

An art dealer: Starting in 1905, his New York gallery was *the place to see* Modern art. Many people saw their first original **Vincent van Gogh** (1853–1890), **Pablo Picasso** (1881–1973), and **Henri Matisse** (1869–1954) paintings in the gallery's austere setting. More important, Stieglitz promoted those young Americans, including **Arthur Dove** (1880–1946), **Georgia O'Keeffe** (1887–1986) —whom he also married— **Marsden Hartley** (1877–1943), and **John Marin** (1870–1953), who were absorbing the influence of the European art he *(continued on opposite page)*

Ridgefield landscape
1913. Oil on canvas

Man-made

All the while, Man Ray was living at home in Brooklyn, commuting daily into Manhattan. After a string of short-lived jobs, he landed a gig with an advertising firm as a graphic artist. Outside of his art classes, Man Ray made solitary trips to the countryside to paint the landscape, and accepted commissions to paint neighbors' **portraits** (*shades of his future photo studio*). A work of 1911, entitled *Tapestry,* is typically **inventive.** It is an abstract study of subtle gradations of color, but instead of paint, he used a material much cheaper and closer to hand: over a hundred little scraps of wool, taken from one of his tailor father's sample books. He signed the work "Man Ray."

As early as 1909, Emmanuel had adopted the pseudonym "Man Ray." Instead of feeling slighted by his rejection of the Radnitzky name, the entire family followed suit; *they all became Rays.* Remarkably, no matter how

much his bohemianism flew in the face of his family's bourgeois aspirations, Man Ray could count on their love and support. Well, almost endlessly, not counting that little episode with the naked lady. To encourage their son's ambition—and to keep him at home—they gave him the family parlor so that he would have enough space for a studio/bedroom. One day, Man Ray brought home two fellow students and a woman. They went into his room and locked the door. When Mother Manya learned that the lady was nude and that the men were drawing her, it was time for Manny to leave the nest.

The Rug ("Le Tapis")
1914. Oil on canvas

BACKTRACK, continued...

endorsed. The gallery changed names and addresses over the years, but the program remained devoutly Modern.

A photographer: He was a brilliant photographer and champion of the medium as an art form.

A guru: Stieglitz knew that selling Modern art to Americans was hardly a matter of dollars and cents. People weren't going to buy what they didn't understand. He was legendary for his urgent (and tireless) talk about the mysteries, beauties, meaning, and need for the art he loved. *He was famous, too, for his cranky personality: If he deemed you unworthy, he would refuse to sell to you— even if his gallery desperately needed the money.*

Sound Byte:

*She was a magnificent, voluptuous blond with ivory skin;
every movement she made expressed languor and sensuality.
I felt I'd be content to watch her and not do any work.*

—MAN RAY, recalling his student days, when he learned
to draw from the nude, *Self-Portrait*, 1963

Man bit by Modernism

Marcel Duchamp
1920

In the spring of 1913, Man Ray moved to Manhattan. His world was a microcosm of the people, places, and events that made the arts tick—slowly—in America. In Europe, **Modernism** was creating a dynamic upheaval within all the arts. But American culture was in a period of transition. The 19ᵗʰ century was over and the Ashcan School was brash, but drearily real. Everywhere, there was talk about change and the desire for something new.

And suddenly, the change arrived in the form of the **Armory Show**, which Man Ray visited in the spring of 1913. It rocked his world. It was his first encounter with the work of **Marcel Duchamp** (1887–1968), an artist who would become Man Ray's closest ally and playmate.

The Armory Show

An initiative of artists from this international exhibition—including Robert Henri—was responsible for bringing Modernism to America. The Armory Show was held in New York at the 69th Regiment Armory (hence the name) from February 17 to March 15, 1913, then traveled to Chicago and Boston, and attracted more than 250,000 (paying) viewers.

The press had a field day ridiculing the wild colors of the animalistic French **Fauvism,** the chip-chop constructions of **Cubism,** the angst of German **Expressionism,** and the furious pace of life as portrayed by Italian **Futurism.**

But all the criticism and satire could not mask a sense of anxiety on the part of Americans, who knew deep-down the real meaning of this foreign invasion: Art would never look the same again! *And it didn't.*

> **FYI:** Modernism consisted of many movements. Fauvism, Cubism, Futurism, Abstract Expressionism, Pop Art, and Postmodernism are among the many movements covered by this 20th-century term.

BACKTRACK MODERNISM

Modernism was a sweeping term used throughout the 20th century to declare a break from the artistic styles of the previous century and from historicism in general. Modernists were determined to represent the present—socially, politically, culturally, and psychologically. **Gertrude Stein** (1874–1946) was a Modernist in literature; **Paul Poiret** (1879–1944) was a Modernist in fashion; and **Erik Satie** (1866–1925) was a Modernist in music.

Modernists embraced **abstraction** (color, structure, words, and even musical notes were seen as objects of meaning in their own right); **real time and space** (a painting, for example, was not a mirror of nature; it didn't *show* reality, but *was part of* reality); and **alternative cultures**. Modernists drew on two alternative sources of inspiration: **popular culture** (comics, movies, the media, fashion, pop music) and so-called **Primitive Art** (non-Western art and artifacts).

Communal Living: 1913–15

In the spring of 1913, Man Ray and his friend, the artist **Samuel Halpert** (1884–1930), took a field trip to rustic Ridgefield, New Jersey. Smitten by the solitude, they ended up renting a simple cabin and setting up a communal household. This became the center of an artists' colony that attracted the Ferrer Center crowd, including the French poet **Adon Lacroix** (pen name of **Donna Lecoeur**). The ex-wife of a colleague, Adon was that irresistible Man Ray woman: beautiful, creative, modern. In Ridgefield, they promptly shacked up together; then on May 3, 1914, they married. At first, country life was romantically basic: They made love, created art, kept warm, wrote each other poems, and counted their pennies. Adon introduced Man to the 19th-century French poets—most notably **Isidore Ducasse** (1847–1870)—who would prove influential on his thinking and on Surrealism in general.

ABOVE
Portrait of Adon Lacroix (Donna Lecoeur). 1913. Oil on canvas

OPPOSITE
Cabin in the Woods (Ridgefield, New Jersey). 1913–14. Oil on canvas

Sound Byte:
He was one of the leading spirits of DADA and SURREALISM and the only American artist to play a prominent role in the launching of those two influential movements.
—THE GROVE ENCYCLOPEDIA OF ART, on Man Ray

Words and pictures

Many of the Ridgefield set were writers and poets, such as **Alfred Kreymborg** (1883–1966), with whom Man Ray published and printed a short-lived homegrown literary magazine called *The Glebe*. Words (poetry, puns) and printed objects (books, magazines, portfolios, pamphlets, announcement cards) would play a constant role in Man Ray's art. In 1915, he and Adon published *The Ridgefield Gazook*, which

featured, on its cover, a cartoon by Man Ray of a pair of copulating insects, punningly captioned: "The Cosmic Urge—with ape-ologies to Picasso." The *Gazook* liberated the defiant humor and spirit that would characterize Man Ray's later art, while his painting at Ridgefield focused largely on learning and reciting the catechism of Modern art, as taught by the Armory Show.

> **FYI:** Little magazines were essential to artists of Man Ray's generation. They created venues for new work—unlikely to be published elsewhere. And they provided grounds for the interchange that Modern artists and writers were enjoying between visual and verbal forms of representation. *Words could be pictures and pictures could be words— an important Modernist idea.*

French-born artist, central to New York Dada and much avant-garde art to follow, Duchamp was the first to enforce a conceptual reality of art—i.e., he made works that declare: **Ideas** *are where it's at.* He spent his career moving between New York and Paris, acting with detachment within the art world, where his influence was always profound. Here are some essentials:

1913: He became instantly infamous when his **Nude Descending a Staircase** (1912), an original combination of Cubism and Futurism, appeared in the New York Armory show and was publicly proclaimed "an explosion in a slat factory." In retrospect, this canvas appears to be one of his most conventional works.

1914: He introduced the **Readymade**, an everyday found object—a shovel,

Tennis Anyone?

In autumn 1915, Marcel Duchamp showed up in Ridgefield with the art collector **Walter Arensberg** (1878–1954). Despite the language barrier, the Frenchman and American hit it off well over a game of tennis. (*Shades of chess games to come.*) They couldn't know it yet, but theirs would prove to be one of the most significant relationships in Modern-art history— as important as Pablo Picasso and **Georges Braque** (1882–1963), the inventors of Cubism! Both men were:

- **intensely individual:** *these guys were eccentrics who wanted to reinvent art.*

- **interested in art as an intellectual practice:** *no matter how big or small, the idea was the thing.*

- **bored by issues of technique:** *take a photo or have someone else fabricate the thing for you, but keep the ideas flowing!*

- **draftsmen:** *they had strong graphic sensibilities and design abilities.*

- **lovers of language:** *especially puns.*

- **lovers of lovemaking:** *images of sex and sexuality inspire them.*

The difference between them was that, over the years, as Man Ray grew more committed to making art—especially painting—Duchamp would put his public efforts into playing chess *and keeping his activities in the studio secret.* **In short, Man Ray became a Surrealist, while Duchamp remained a hardened Dada.**

Click!

Man Ray had the first of three solo exhibitions at the Daniel Gallery in October 1915. The show was not a critical success, but became a financial one when a collector stopped in after the exhibit had closed and bought six works. Man Ray used the cash to hightail it from rustic Ridgefield (and another depressingly cold winter) back to Manhattan, where he and Adon eventually separated.

The most important event attached to this first exhibition was that, for the first time, **Man Ray picked up a camera.** After hiring a photographer to take pictures of his paintings (for press and documentary purposes), he was unhappy with the results and decided he could do a better job himself.

BACKTRACK, continued...

a bicycle wheel, a urinal—that he presented as an original work of art.

When exhibited in a museum or gallery, the Readymade challenges the system of conventions that can transform any object into a work of art. *It's a work of art because an artist says it is; because it occupies the place of art (the wall, a pedestal); because it's worth so much money; because you perceive it to be art.*

1915–23: He worked on his masterpiece, ***The Large Glass (Bride Stripped Bare by Her Bachelors, Even)***, a painting on glass of machinelike figures and parts, with a complex iconography about sex, chance, and consequences. Smart and strange, the painting explores the process of conceiving and making a work of art—or a work of creative strategy.

1923: He devoted more time to playing chess than to making art.

A BRIEF HISTORY OF PHOTOGRAPHY

Photography was invented in 1839 and, by the time Man Ray came to it almost 80 years later, people still hadn't decided what to make of it. *Was it simply a tool for creating accurate, objective documents? Or did it have artistic possibilities, as did painting?* The history of photography is built on these very questions. Here are the essentials:

Pictorialism: The hallmarks of this worldwide 19th-century movement were soft, almost fuzzy prints with a heavy dose of atmosphere. Like the painters of the period—such as the Impressionist **Claude Monet** (1840–1926) and

the romantic **James Abbott McNeill Whistler** (1834–1903)—these photographers wanted to show the world the way the eye sees it: shifting in and out of focus. Key figures were **Gertrude Käsebier** (1852–1934), **Julia Margaret Cameron** (1815–1879), **Clarence White** (1871–1925), and, in the early part of his career, **Alfred Stieglitz** (1864–1946).

Straight Photography: This 20th-century movement emphasized sharp focus, structured composition, and excellent darkroom technique. *The camera **wasn't** an eye; it was an apparatus.* So, why shouldn't photography

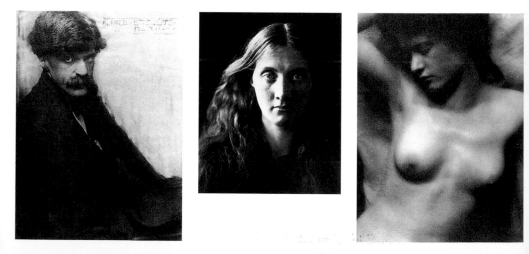

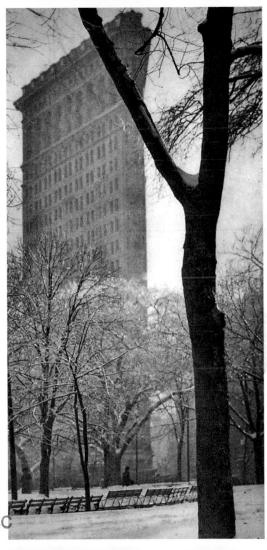

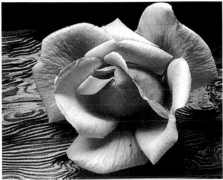

celebrate the fact that it could be so accurate? Stop time? Frame the world? At least, that's how Alfred Stieglitz saw it, when he conceived and promoted this typically American school of photography, whose star students included **Edward Steichen** (1879–1973), **Ansel Adams** (1902–1984), and **Imogen Cunningham** (1883–1976), among others.

ABOVE
Ansel Adams. *Rose and Driftwood.* 1932

RIGHT
Edward Steichen. *The Flatiron Building.* 1903

OPPOSITE PAGE (Left to Right):
Gertrude Käsebier, *Alfred Stieglitz* (1902)
Julia Margaret Cameron,
Mrs. Herbert Duckworth (1867)
Clarence White, *Torso* (1909)

But in Europe, following World War I, things started shaping up differently within the world of photography:

In Russia: As part of the Russian Revolution, artists such as **Aleksandr Rodchenko** (1891–1956) abandoned the "navel point of view" (i.e., camera in front of photographer's belly-button) in favor of sharp and acute angles of vision that made viewers feel as if they were behind the camera. These works revolutionized the role of the viewer, who was inspired to envision the world in a new way.

In Germany: At the Bauhaus school of art and design, **László Moholy-Nagy** (1895–1946) was inventing ways for photography to embody both industrial and artistic processes. The results pushed photography toward extreme abstraction and accuracy. The picture could

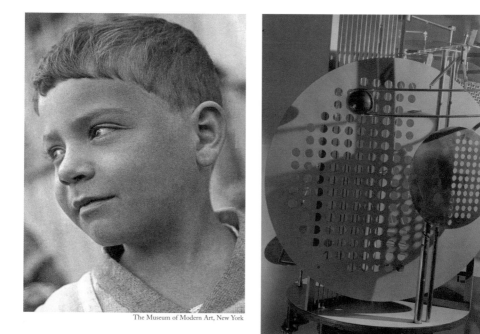

The Museum of Modern Art, New York

be richly graphic in its detail, but, you might still have no idea what you were looking at.

In France: As part of the Dada movement, artists such as **Hannah Höch** (1889–1978), **Raoul Hausmann** (1886–1971), and **Christian Schad** (1894–1982) were cutting and pasting together photographic images. The collaged results looked as if a bomb had been dropped, shredding reality—in the same way that the war had torn apart the stability and sense of meaning in the world.

These three threads all fit into **Surrealist photography** as it evolved in Europe starting in the mid-1920s. The hallmarks of this alternative approach were a sense of subjective experience (pictures that disturbed, aroused, or upset the viewer), of movement (blurry was fine), and of mystery (what was this picture really about?). Photography could be about experiment and **invention,** about allowing for accident and **chance.** *It could be about snapping the shutter and seeing what developed.* Surrealist photography exploited our basic assumption that photography presented reality as we "saw" it and then shocked us by going beyond that reality, or by undermining it. Key figures included **Brassaï** (1899–1984), **Dora Maar** (1909–1998), **Lee Miller** (1907–1978), and, of course, Man Ray.

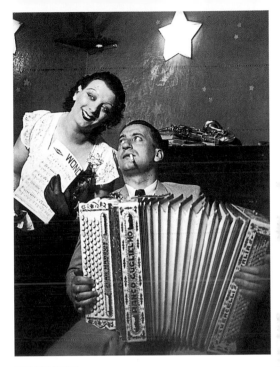

ABOVE
Brassaï. Kiki with her accordion player at the Cabaret des Fleurs. c. 1932

OPPOSITE LEFT
Aleksandr Rodchenko. *Portrait of a Boy*. 1932

OPPOSITE RIGHT
László Moholy-Nagy. Detail of the *Light Display Machine*. 1922–30

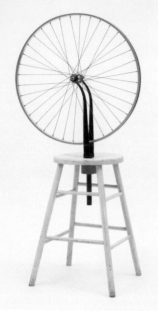

ABOVE
Marcel Duchamp. *Bicycle Wheel*
1951. Metal wheel mounted on
painted wooden stool

RIGHT
Self-Portrait. 1916
Painting on cardboard
with artist's handprint

New York has two Dadas: 1916–20

Basically, Man Ray was painting in his modern way when
Dada took hold. Gradually, while experimenting with his
art, Man Ray emerged, with Duchamp, as a leader of the

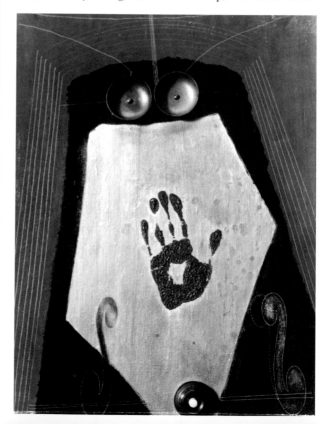

American version of this European avant-garde movement. In Man Ray's 1916 painting *Self-Portrait*, one gets a glimpse of what would follow in the years ahead:

- **Found objects:** Attached to the front of this abstract oil painting one sees two bells and a push button. By 1920, Man Ray was using found objects almost exclusively to make his Dada art. (*Note the pair of violin sound holes on either side of the button: shades of violins to come!*)

- **Provocation and participation:** This work was an invitation to violate one of the sacred rules of viewing art: *Do Not Touch!* Dadaists welcomed the viewer's interaction with their art.

- **Humor:** Man Ray knew that pushing the button would be irresistible and would give the viewer pleasure.

- **Anti-Machinery:** When the button is pushed, nothing happens. *And that's what makes it a work of art,* said Man Ray.

- **Radical gestures:** Man Ray slapped his handprint in wet paint, smack in the center of this self-portrait. *This signature marked the end of Man Ray's painting as a tactile art. From this moment onward his work would appear increasingly untouched by human hands.*

BACKTRACK
DADA

Does the word *Dada* sound like nonsense? Its practitioners were people who drew words out of a hat and called them poetry; who shaved their pubic hair and called it art; who exhibited a urinal in a gallery and called it sculpture. Dada was an anti-art movement that erupted as an expression of disgust with World War I. It aimed to shock people into resistance against authority. It was characterized by anarchic and absurd gestures that mocked the sanctity of art, and by attempts to separate words (and images) from their meanings. The name *Dada* is French for "hobbyhorse." Legend has it that the word was pulled randomly from a dictionary to name the movement. The group's activities were centered in Zurich, and in 1920 the poet **Tristan Tzara** (1896–1963) introduced a variation of the movement in Paris that would soon set the stage for Surrealism.

New York Dada: Separate, but related to the European movement, New York Dada (which took the name Dada late in the game) began to percolate in late 1915 around a cartel of international figures that included Spanish artist **Francis Picabia** (1879–1953), the Frenchman Marcel Duchamp, the Mexican **Marius de Zayas** (1880–1961), and the American Man Ray. Less affected by the war, they were fascinated by machines, which were making equal havoc of the modern world. With humor and detachment, they created works that typically blurred the distinction between humans and machines, and that made extreme predictions about a machine-age future in which everything from sex to religion would be machine-driven.

Dada's Mama: At the start of the 20th century, women were enjoying newfound freedom, as witnessed by their bobbed hair, short skirts, smoking, and active sexuality. For Dadaists, this translated into images of the Machine-Age woman **as machine**, ready to grind, gyrate, light up, and go all day and all night. There were some sexy metaphors here, but these images also suggested some anxiety on the part of men, who might be reduced to servicing these (sex) machines. In a pair of photographs, Man Ray represented the lower part of Woman as a row of clothespins, ready to snap on to whatever. He made Man a **hand-operated** eggbeater *(i.e., get the safest sex in the city, fellows, by turning your own crank).*

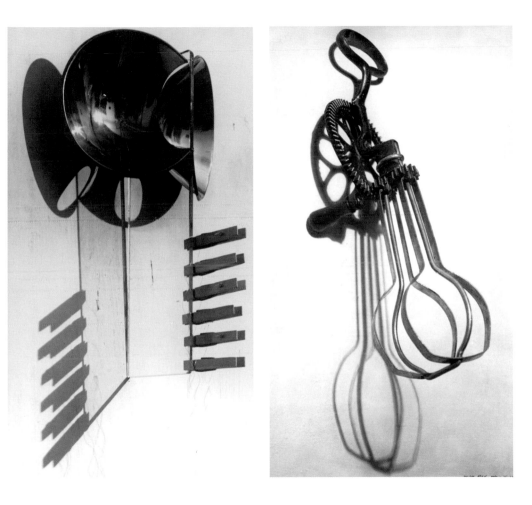

Lou & Walt & Kate

New York Dada took shape around two circles that both involved collectors. In the fall of 1916, the **Society of Independent Artists** was formed with Man Ray as a director. The group began to meet regularly at the apartment of Walter and **Louise Arensberg** (1879–1953). It was a lively, often wild, salon scene with drinking and dancing— and Louise on piano—as well as the evenings' agenda of heady chat. In April 1917, the society held its first exhibition, and Duchamp's notorious submission entitled *Fountain*—a urinal inscribed with the fake signature "R. Mutt"—was banished from the show. Man Ray exhibited *The Rope Dancer Accompanies Herself with Her Shadows*, 1916.

FYI: **In good company**—When the **Arensbergs** lived in New York from 1914 to 1921, their apartment at 33 West 67th Street was *the* place for American Modernists to meet members of the European avant-garde. In contrast to the party-going Arensbergs, the collector **Katherine Dreier** (1877–1952) promoted the New York avant-garde as a cause, like prohibition: It was, for her, as urgent as social reform. She was serious about Duchamp, who inspired her to join him and Man Ray in cofounding, on April 29, 1920, the **Société Anonyme**. Man Ray coined the name, which he thought meant "Anonymous Society." When Duchamp informed him that "anonyme" simply meant "company" or "incorporated," he liked it even more.

THE ROPE DANCER ACCOMPANIES HERSELF WITH HER SHADOWS, 1916

Oil on canvas. 52 x 73 3/8" (132 x 186.37 cm)
The Museum of Modern Art, New York; Gift of G. David Thompson

The image of the tightrope walker, treading a thin line between life and death, expresses the basic symbolic value of this image. Man Ray claimed that he was in the process of cutting out silhouettes of dancers from different colors of contact paper when he noticed the cut-away bits on the floor. These bits interested him more than the figures he was making, so he used them instead. He claimed this selection was the result of an accident. This work looks untouched by human hands. The figurative elements look ready to switch into mechanical motion—*flapping, turning, spinning*.

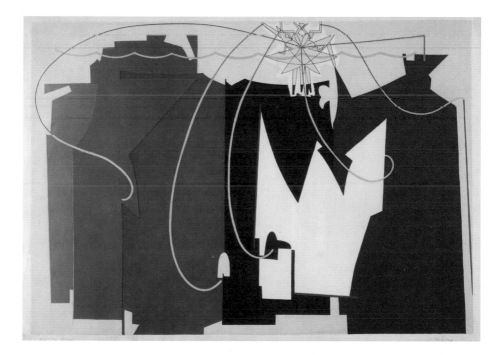

Dada for hire

Dreier hired Man Ray to photograph the Société Anonyme's exhibitions and art collection. He participated in the society's opening group show, held in January 1921, with *Lampshade,* one of his first objects (see page 36). It was basically a damaged paper shade that Man Ray had remade using painted tin. Man Ray told a nice little story of a janitor who found the (broken) lampshade and threw it in the trash can the day before the gallery opening. This **accident** prompted the artist to have the lampshade remade in metal. *Truth be told— Ms. Dreier, seeing how delicate the object was, actually suggested that he think about how to make it permanent.*

Now that **Man Ray was in full Dada swing,** he made:

- **Objects:** Using everyday items, often mass-produced, Man Ray created objects, like *New York,* a glass bottle of ball bearings (see page 36) that captured the tension of working and living bottled up in a landscape of skyscrapers. These objects relate to Duchamp's **Readymades** (see *Bicycle Wheel* on page 28) by shifting attention from the art object to the *ideas* that transform it into a work of art.

- **Aerographs:** Paintings made with an **airbrush**—a paint pump used for retouching photographs and graphic arts. Man Ray was familiar with this process from his commercial work. The machine-made results were absolutely modern, even photographic.

The Three Graces, or Nudes ("Les trois graces"). 1920 Aerograph that shows the headless, footless bodies of three women

BELOW

LEFT
Compass
1920
Magnet and
gun, hanging

CENTER
New York. c. 1920
Ball bearings
in glass jar

RIGHT
Lampshade
1921

■ **Photographs:** The ultimate Machine-Age picture maker, Man Ray used the camera in a number of ways: To document his art; to make art; and, from someplace in between, to take pictures of found objects, which subsequently disappear, only to exist in photographs. The great example of this is *The Enigma of Isidore Ducasse* (1920). Here, a lumpy object appears wrapped in thick cloth that is tied with rope. The title refers to one of Man Ray's favorite French poets, a champion of literary freedom, whose images combined ordinary objects in extraordinary ways. *But what lies hidden? A body, a sculpture, a sewing machine?* We shall never know. Man Ray purposefully dismantled the set-up, keeping its contents a secret that eats at us every time we view this strange photograph.

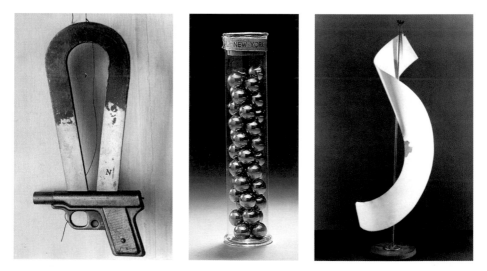

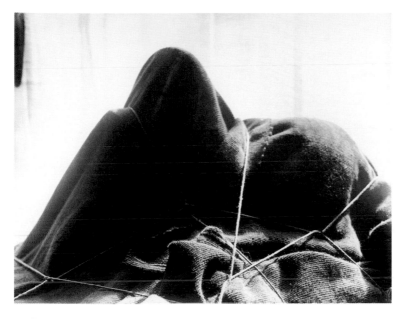

The Enigma of Isidore Ducasse 1920 Photograph of unidentified object or objects wrapped in thick fabric and tied with rope. Man Ray intended the viewer to solve a riddle ("enigma") in order to find out what the contents of the fabric were, but to do so the viewer had to be familiar with the writings of Isidore Ducasse.

■ **Print:** He contributed to all the hip Dada 'zines: *Wongrong*, *291*, *391*, *The Blind Man*, and edited the one and only issue of *New York Dada*. Published in April 1921, this magazine was a crazy compilation of (mostly unsigned) poetry, cartoons, art, and found images.

> **FYI:** Little is known about the life of French poet Isidore Ducasse—a.k.a. the Comte de Lautréamont, who wrote *Les Chants de Maldoror* (a song cycle about a young man's fantastic adventures, including making love to a shark) in which he penned the phrase that would express one of Man Ray's and the Surrealists' favorite images: *Lovely as the fortuitous encounter on a dissecting table of a sewing machine and umbrella.*

Grumpy Dada

Still in New York, Man Ray was beginning to harbor some resentments: *Why, if I'm so radically Dada, aren't I getting more serious attention (and cash) for my work?* He suspected that the Arensbergs and Dreier were more interested in his ability as a house photographer than as an artist. When Dreier invited him to give a lecture on February 16, 1921, he delivered a sarcastic speech by way of a fanciful tale: *When in the gallery photographing other people's art the other day, he chanced to snap the thoughts of a viewer, whose head, the developed pictures revealed, was full of revolutionary thoughts against the dealers, collectors, and all those who made money from artists.* Miss Dreier was not amused. Fed up with New York, Man Ray sailed for France on July 14, 1921. With the exception of a few trips back to the States, he would be an American in Paris for the next 19 years.

Dust Bunnies

In the years before and after his trip to Paris, Man Ray and Duchamp worked on some of their most important collaborations, with Man Ray as photographer and Duchamp (most often) as performer. In *Dust Breeding,* Man Ray snapped a detail of Duchamp's *The Large Glass* that was lying in the dusty studio, filthy; it was as if the artist were raising dust for some purpose, or simply affirming art's lack of purpose *by letting it sit around gathering dust all day.* The image is as enigmatic

as a moonscape. In *Rrose Sélavy*, Man Ray portrayed Duchamp in drag as his feminine alter ego. *A typical Dada inversion: If women are going to enjoy more (male) freedoms, why not bend genders in both directions? If you say* Rrose Sélavy *out loud slowly in French, it sounds like* Eros! C'est la vie, which means *Eros! That's life.*

Man Ray made another portrait of Duchamp, this time as the devil— with horns made out of shaving cream—that Duchamp used to grace the 1924 Monte Carlo Bonds that he contrived. Eager to learn the laws of chance, Duchamp issued these "bonds" to fund a trip to the casino, where he tested his scheme for winning at roulette.

NEAR RIGHT
Rrose Sélavy. 1921
Photograph of
Marcel Duchamp
in drag

FAR RIGHT
Portrait of
Marcel Duchamp
with shaving
cream in his hair.
Variant of image
used for Duchamp's
Monte Carlo
Bonds

OPPOSITE PAGE
Haircut
(Marcel Duchamp)
1921

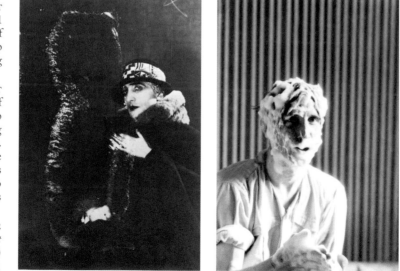

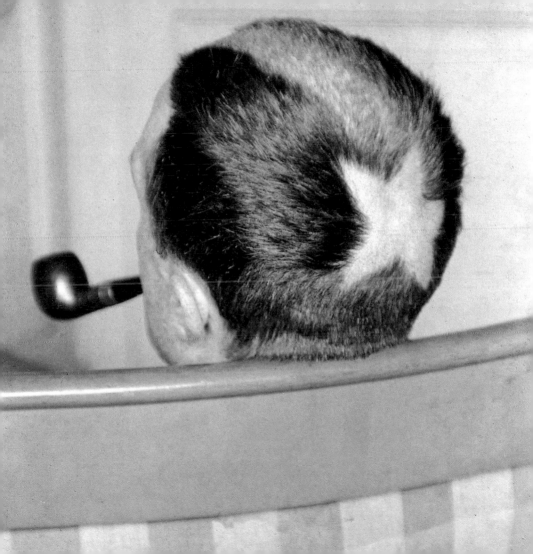

American in Paris: 1921–40

Paris was paradise for Americans during the 1920s: The dollar was strong, and life was sweet and easy, with flowing wine, excellent company, and dynamic culture. Not only did Paris offer a tradition of great art and an established avant-garde, but, as a modern Mecca, the city attracted people from around the world. Everyone wanted to

Nusch Éluard with reflection of her husband Paul Éluard in the mirror. 1932. Photograph

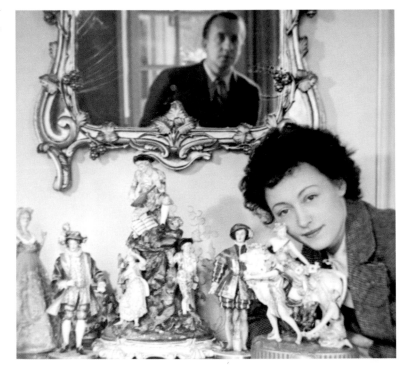

be there, and many of them were: **Ernest Hemingway** (1899–1961), **James Joyce** (1892–1941), Pablo Picasso, **Isadora Duncan** (1877–1927), and Man Ray himself, who arrived in this cosmopolitan culture on July 22, 1921.

Man Ray Newborn

Duchamp was there to meet him—and it was a good thing, since Man Ray spoke no French. He soon became fluent, but would never lose his thick Brooklyn accent. The first day was glorious. They went to Café Certa and met the Dadaists, whose members included **André Breton** (1896–1966), **Paul Éluard** (1895–1952), and **Philippe Soupault** (1897–1990). The poet Soupault offered Man Ray an exhibition that would take place at his bookstore, Librairie Six, in December 1921. *What to do in the meantime?* Over the summer, Man Ray and Duchamp continued their Dada collaborations, and Man Ray got to know his new home.

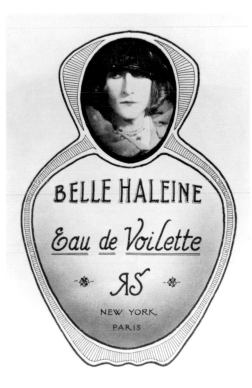

Belle Haleine—Eau de Voilette ("Toilet Water") Gelatin silver print of Marcel Duchamp, perfumed and behatted in drag as Rrose Sélavy. 1920–21
8 3/16 x 7" (20.6 x 17.75 cm)

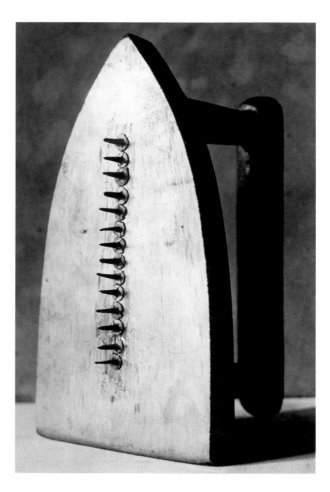

GIFT ("CADEAU"), 1922

Iron and tacks/nails. Original work has been lost

What: It's just what you see, but the story behind it is great!

The Scene: It was the opening of Man Ray's first exhibition in Paris, on December 3, 1921, at Librairie Six. The glitterati of the art world were in attendance—attracted, no doubt, by the amusing announcement that Man Ray had created for the occasion. (The biographical statement presented him as a rich American who had decided to cash in his assets and become an artist.)

The Motive: The show consisted mostly of works that he had brought with him from New York— photos, aerographs, objects, and so forth. Suddenly, he was inspired to add a new work, made in Paris, especially for this occasion. *But first he had to make it*

The Old Man: He spotted an old man—none other than the avant-garde musician Erik Satie— and asked him to accompany the artist to a nearby shop to help negotiate the purchase of an iron, some tacks, and a pot of glue. *Man Ray's French wasn't very good yet.*

The Mystery: What attracted Man Ray to these items was an ordinariness that made them practically invisible as individual objects until you saw them stuck together in a way that made them unforgettable.

It was the First French Dada Object: Like his other Dada objects, this one rendered a useful object useless. But only in a utilitarian way. *That is, you couldn't iron a shirt with it!* Otherwise, Man Ray insisted, the iron was quite handy at prompting interpretations from viewers and at creating mystery. *But it's anyone's guess why he called it a gift.*

Parting of the Dada Ways: There was an important distinction between Duchamp's **Readymades** (see *Bicycle Wheel* on page 28) and Man Ray's **objects** (as shown on page 36). Both used found objects, but Duchamp created simple transformations (from urinal to artwork, for instance), whereas Man Ray, especially after leaving New York, produced objects that triggered feelings of anxiety or suspense. They were about mystery.

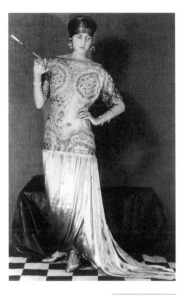

Trouble in Paradise

There was only one problem: money. An Ohio coal baron had advanced Man Ray the sum of $500 plus $50 per month against acquisitions of future works. But when it came time to collect his commissions, Man Ray's patron found himself repulsed by the new Parisian works and settled for some of Man Ray's old Modernist paintings.

In need of an income, Man Ray grabbed his trusty camera and began photographing other artists' works again. One day in August 1921, a friend introduced him to the fashion designer **Paul Poiret** (1879–1944). The latter zeroed in on Man Ray's talent and offered him a job photographing models at his posh Parisian fashion salon.

Man Ray could then sell the pictures to fashion magazines, since he retained ownership of his work. This was the start of Man Ray's successful relationship with the most innovative designers in Paris and with the world of fashion publications.

ABOVE
Peggy Guggenheim in a dress designed by Paul Poiret for one of her costume balls in Venice. 1925

OPPOSITE
Denise Poiret in a dress designed by Paul Poiret in front of a sculpture by Brancusi. 1922

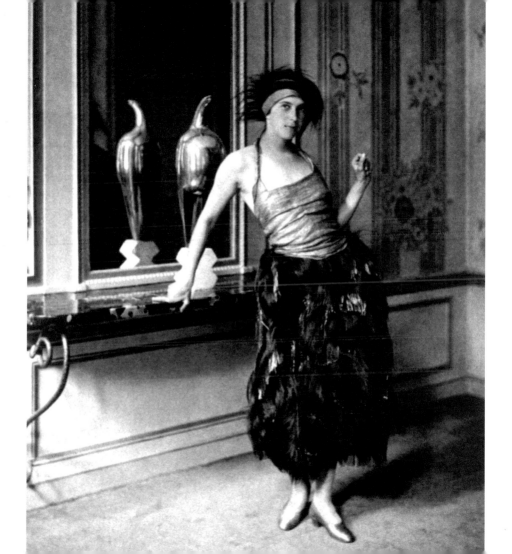

MAN RAY A LA MODE

THIS PAGE
(from left to right):
Elsa Schiaparelli, 1934;
Mainbocher's triumph in black,
in *Harper's Bazaar*, 1936;
Fashion "letter L," c. 1938.

OPPOSITE PAGE
Untitled. 1937. Giacometti's
Albatross dress by Chanel.
Extract from *Harper's Bazaar*

Man Ray was one of the first artists to make contemporary art fashionable. During the 1920s and 1930s, in the midst of a busy career as an artist, he had become a top fashion photographer. Starting in 1921, he shot collections by **Coco Chanel** (1883–1971), Paul Poiret, **Elsa Schiaparelli** (1896–1973), and **Mainbocher** (pseudonym of Main Rousseau Bocher, 1891–1976) on assignments from *Vogue*, *Vu*, and *Harper's Bazaar*. In 1934, with business really booming, he was hired by *Harper's Bazaar* to work with the dynamic duo, editor **Carmel Snow** (1887–1961) and art director **Alexey Brodovitch** (1898–1971).

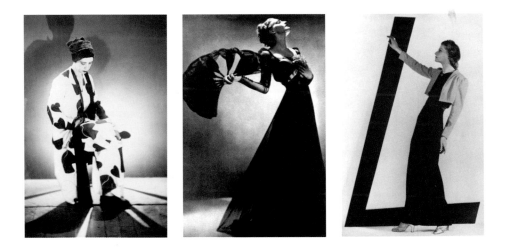

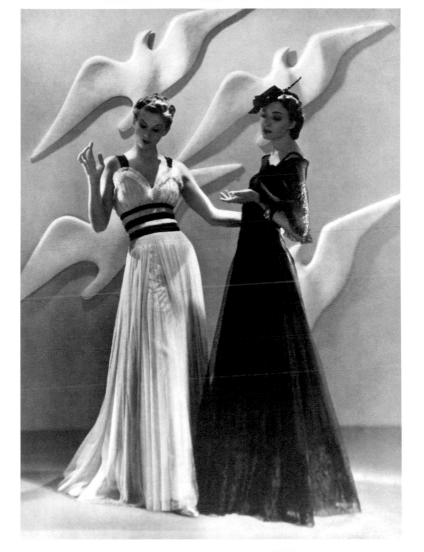

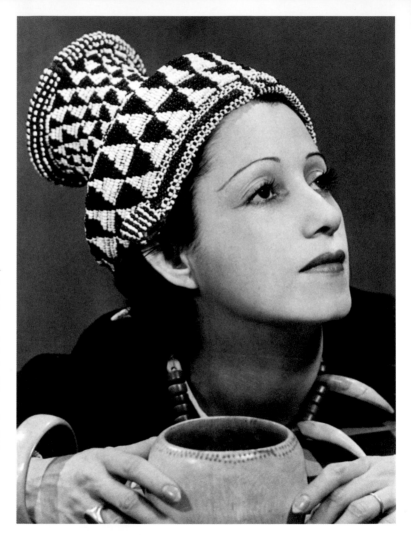

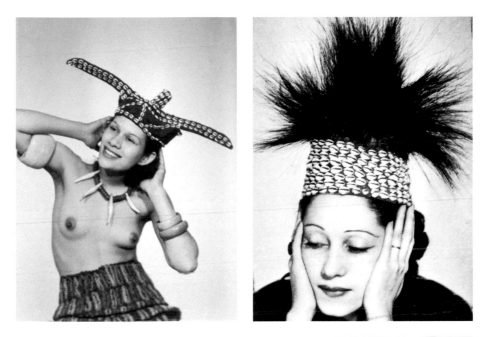

For Man Ray, fashion was never just a day job. Look what he brought to it:

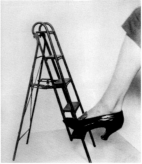

- **Dreams, mysteries, ambiguity:** The sensibility that Man Ray brought to his art made his magazine work spellbinding. He created elongated perspectives that looked unreal.

- **Found objects:** His love of found *objects* extended to found *models* (i.e., he invited friends and artists to pose for him).

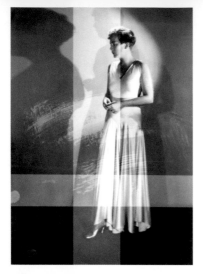

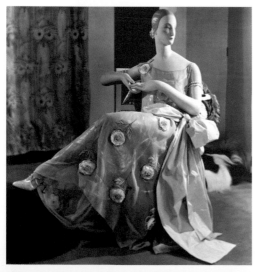

■ **Fetishized females:** In the French fashion world, models are called "mannequins," which is exactly how Man Ray liked to see women in his art: as objects of desire, which he (and the viewer) may possess as images. Note the remoteness of his models: They look like sculptures, their hands drooped in midair, ready to move when instructed to by the photographer.

■ **Rayographs, solarization, double exposures:** He applied the same inventive techniques throughout his fashion and art.

■ **Avant-garde art in the pages of pop culture:** He posed models with paintings and sculptures, shooting the hottest new gowns with the hottest new art—all looking *absolutely fabulous!* In one divine spread, a model languishes on a couch beneath his own painting of the flying lips. In another, a model's furry hat rhymes with the shape of a nearby Brancusi sculpture. He hired artist friends, such as the sculptor **Alberto Giacometti** (1901–1966), to design props.

■ **Fashion and Surrealism:** What a love affair! The fashion world embraced Surrealism, and vice versa. Man Ray showed his fashion photos in the avant-garde magazine *La Révolution Surréaliste*.

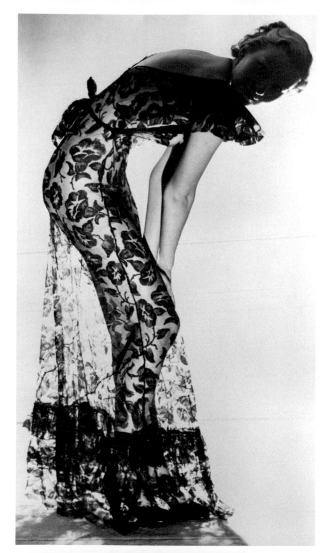

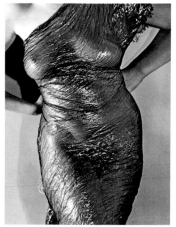

Sound Byte:

In the early 1920s in Paris, one learned quickly that if you were to have your photographic portrait made, you would be wasting your time unless you gained yourself a sitting with the only resident master of this prestigious art: Man Ray.

—TIMOTHY BAUM, *Man Ray's Paris Portraits: 1921–39* (1989)

Making it in Montparnasse

If you were an artist in Paris during the 1920s, the neighborhood of Montparnasse was the place to be. Early in December 1921, Man Ray moved there, first to the hip *Hôtel des Écoles*, where one of his first visitors was his neighbor Gertrude Stein, who arranged for him to come to her house and take her portrait surrounded by her amazing collection of Modern art. The Hôtel was lively, but cramped and that's where Man Ray made his first *rayographs* (also called *photograms*). In July 1922, he moved into a new building at 31 bis, rue Campagne Première. It became headquarters for an extremely lucrative business, for fashion, portrait, and commercial photography. (His work proved to be so popular that eight years later, in 1930, the city of Paris hired him to create a portfolio promoting the use of electricity. Indeed, Man Ray's radiant nudes and eroticized toasters were enough to turn anyone on to wattage!) By 1922, Man Ray had established himself artistically and professionally in Paris. But what about *romance?*

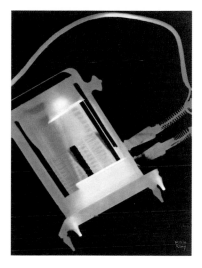

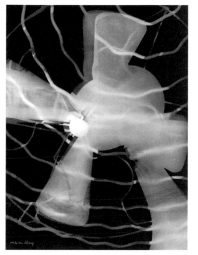

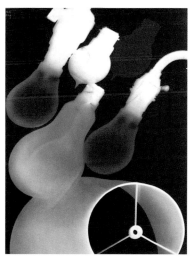

Promotional portfolio made for the Electrical Distribution Company of France in 1931 *Clockwise from top left:* Photoengravings of toaster and battery; electric fan; lamps and shade; electricity and woman's torso

RAYOGRAPHS (OR PHOTOGRAMS)

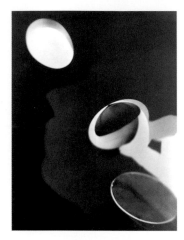

What is a rayograph? A photograph taken without a camera. If you set an object directly onto a piece of photographic paper, expose it to light, and develop the paper—voilà! You get an x-ray-like image of white objects set against a black background. Man Ray called the process "painting with light."

Man Ray's version of rayographs: Man Ray made his first such image in 1921. He explained that he had discovered the technique (you guessed it!) *by accident*, while in the darkroom developing some fashion photos. He was thrilled with the results and dubbed the technique *Rayography*, then promptly added it to his repertoire of experimental picture making.

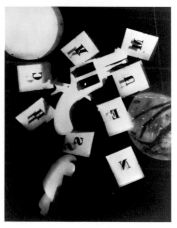

History's version: In fact, the photogram was the oldest photographic technique, used as early as 1835. Man Ray was among a number of artists who adopted it during the early 20th century. No one really knows who invented it, but it certainly wasn't Man Ray. For example, the German photographer Christian Schad had made some photograms in 1918 and called them *Schadograms*. The Dada artist Tristan Tzara described the photograms as "Dada photography" in his introduction for Man Ray's 1922 portfolio of rayographs, *Les Champs Délicieux*.

TOP
Rayograph. 1922. Extract from the Kiki series

BOTTOM
Rayograph. 1924

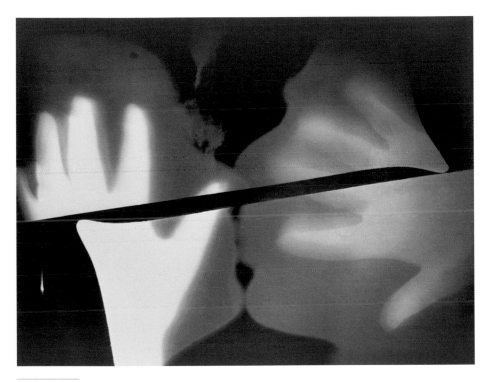

The Kiss. 1922. Rayograph of Man Ray kissing Kiki de Montparnasse

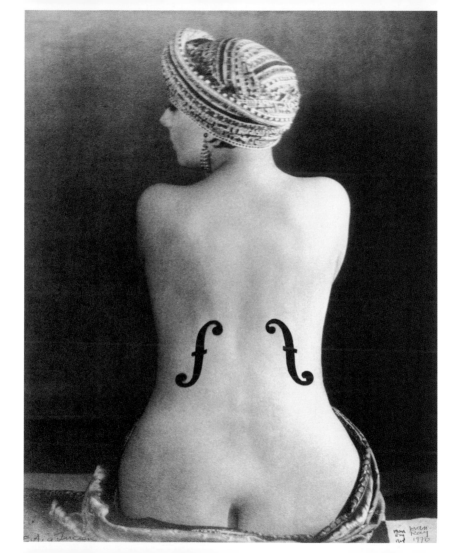

Enter Kiki of Montparnasse

Her real name was **Alice Prim** (1901–1953), but, like Man Ray—and Jay Gatsby—she reinvented her identiy and aura, and renamed herself **Kiki de Montparnasse**. Alice was a country bumpkin, but Kiki was the spirit of Montparnasse, ready to sing, fight, or flirt any hour of the day or night. Man Ray met her in a café one evening when Kiki was being noisily tossed out for seeming to be a prostitute—*heavens, she's got no hat!* Until, of course, Man Ray invited her to join him at his table. They went to a movie, and held hands. By the end of 1921, she had moved into his studio. His photographs of her reveal that he found Kiki absolutely:

Kiki de Montparnasse 1922

- **Moving:** At first she was shy in front of the camera, which Man Ray found odd, given that she supported herself as an artist's model—and that she was such a sexpot! Then she took off her clothes, and Man Ray saw that she had no pubic hair! *No wonder the poor girl was camera-shy.*

- **Mysterious:** *Why did Man Ray draw violin sound holes onto this photograph of Kiki's back?* The title, *Le Violon d'Ingres,* is a clue. It means "Ingres' violin" and is a French expression for "hobby": Ingres was a famous French painter who dabbled in music. Man Ray added his own note of punning humor by plopping a turban onto Kiki's head: Ingres spent his time painting harem scenes of voluptuous nudes seen from the back. *Nice hobby!*

- **Modern:** See *Noire et Blanche* on pages 66–67.

OPPOSITE
Le Violon d'Ingres 1924. Photograph of nude and turbaned Kiki de Montparnasse as a Surrealist icon, with sound holes on her back to suggest a violin

PORTRAIT OF JAMES JOYCE, 1922
Gelatin silver print

When: From 1921 to 1939, Man Ray ran a portrait studio, where he photographed socialites and celebrities of the arts and cultural worlds who were flocking to Paris at the time. Here are two examples that illustrate the essentials of Man Ray's extraordinary body of work in this genre.

Why: But first, a historic nugget. Man Ray's portraits had an important precedent that can be found in the art of the photographer **Nadar** (1820–1910). Nadar's real name was Gaspard-Félix Tournachon, but a snappy handle wasn't the major reason that Man Ray related to him. In 1853, Nadar opened a photo studio in Paris, where he made portraits of all the famous people who had arrived there. His works were disarmingly natural and direct. The Nadar studio was carried on by his son, Paul, into the 1930s. Man Ray knew the history and success of Nadar's work and hoped to create a similar success for himself.

Who: The portrait of the celebrated Irish author James Joyce was taken the same year that his masterpiece, *Ulysses*, was published. Joyce's breathtaking novel would influence literature as profoundly as Freud's ideas had affected the study of psychology. The work takes into account all the chatter, impulses, desires, swearing, memories, jokes, and so forth, that stream through one's mind.

Sight of Sore Eyes: Many consider this to be the quintessential portrait of Joyce, whose sensitive eyes caused him much pain. He averted them from the bright lights of the studio in a way that enabled Man Ray to capture some of Joyce's exhaustion from having been thrust into a cultural torment that would eventually lead to his being proclaimed a literary genius.

PORTRAIT OF THE MARQUISE DE CASATI, 1922

Gelatin silver print

Who: The Marquise de Casati was an eccentric fixture of Parisian aristocratic society.

What on earth? It was an **accident**! A double exposure. Man Ray thought he had ruined the picture. *But the client loved it!* She exclaimed that it *captured her soul.* In fact, she called it *The Portrait of My Soul.*

Blast off! This picture launched Man Ray as a society photographer. Casati ordered dozens of prints, and sent them to all her rich friends, who in turn wanted to have their portraits made by this Man Ray fellow, too.

Surreal Stratosphere: Through his new clientele, Man Ray was invited into the eccentric world of the aristocratic elite—elaborate costume balls, silly game-filled country weekends, and so forth. (At one party, he projected film onto the dancing guests, all of whom had been instructed to wear white.) *He was valued as an amusing figure—a kind of court photographer but was never taken seriously as an artist by them.*

Photomat: Man Ray claimed that he treated his portrait studio like an automatic photo-booth. You walked in the door, and *flash!*—he took your picture. The sessions were quick, with few shots, all taken very close up. But a recent exhibition of Man Ray's contact sheets tells a some what different story. Yes, he snapped amazingly few shots (professional photographers usually shoot rolls of film per session), but they were usually taken from a distance: The faces we see are details cropped from the original negatives. In other words, these portraits weren't made automatically with the press of a button; they were expertly composed by the artist on paper after the picture had been taken.

Gene and Connie

Jean-Eugène Auguste Atget
Photographed by
Berenice Abbott. 1927

Besides Kiki, there were two other Montparnassians who deeply impressed Man Ray with their determined individualism and elegant poverty. The photographer **Jean-Eugène Auguste Atget** (1856–1927) was ancient in every way—an *old* man, who used *old* equipment. (Man Ray lent him a new camera, but the equipment moved too fast for Atget.) The old man maintained old-fashioned views and made a humble living selling photos to artists for study purposes. He called himself not a photographer, which sounded too artistic to him, but an *archivist*. You know that Man Ray—who considered his photos to be *work* and his paintings to be *art*—would have relished this crotchety guy. But he also loved Atget's pictures—especially the shop windows

filled with weirdly lifelike mannequins—and was responsible for bringing them to the attention of the Surrealists.

Just blocks from Man Ray's modern studio apartment, the sculptor Constantin Brancusi lived like a peasant, grilling meat on a fire, surrounded by stone and wood furniture, hand-hewn like his art. The two enjoyed one another's company. Brancusi's sense of abstraction informed Man Ray's photographs. And Man Ray taught Brancusi how to take pictures. (Man Ray acquired a giant wooden screw from a wine press that resembled Brancusi's masterpiece *The Endless Column*.)

Constantin Brancusi. 1930

FYI: In 1923, Man Ray hired a young American assistant, **Berenice Abbott** (1898–1991), in part because he liked the fact that she knew little about photography. But she quickly learned and proved to be a talented photographer in her own right, opening a Paris portrait studio that rivaled her teacher's. She also learned to admire Atget's work and became, at his death, one of the caretakers of his great archive of works, now in the collection of the Museum of Modern Art, New York.

Berenice Abbott. 1930

NOIRE ET BLANCHE (BLACK AND WHITE), 1926

Gelatin silver print

What: *Noire et Blanche* is an example of pure Modernism. Man Ray photographed Kiki with an African mask. Kiki invented her own name; she sang, painted, wrote her bohemian life story, and acted in movies. In fact, she generally embraced life *hard!* She was Man Ray's mistress and muse of the 1920s. This is just one of the many important (and gorgeous) photographs he made of this inspiring woman.

Black mask vs. White flesh: By abstracting both heads away from their usual context (i.e., human bodies), Man Ray makes both of them objects. And while it's normal to see masks as objects, some viewers may find it disconcerting to see a woman's head lying on a table like a big egg. Man Ray makes this kind of Surreal gesture with floating female body parts in many of his works.

Primitive vs. Modern: The severe simplification of this image is the kind of lesson in abstraction that Modern artists (from Picasso to Matisse) were learning, by looking at African and other so-called primitive cultures. Head-as-egg is a motif that comes straight out of Constantin Brancusi's sculpture, which Man Ray greatly admired.

A pair of fetishes: The mask represents a magical primitive *fetish*; the woman's passive head depicts an erotic, Surrealist one.

Doubling: This pair of heads also poses the question: Which head is more real? As transformed by photography, the mask (a sign of the unconscious) comes to life, while the human head looks dead. Of course, if you're a Surrealist, it's possible to enjoy both of these realities simultaneously.

Shadow vs. light: The essential Modern meaning of *Noire et Blanche* would never be lost on a punster like Man Ray: *It's a photograph.*

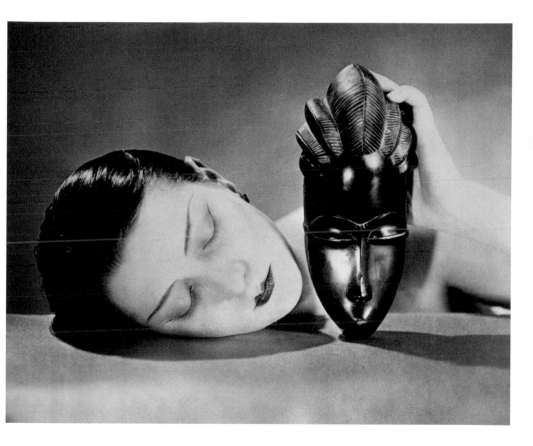

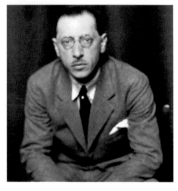

Cinema→Man Ray→Cinemanray

One day, Man Ray's friend Tristan Tzara stopped by the studio to warn him that he had just posted a flyer announcing that a film by Man Ray would be presented the next day at an all-Dada evening, with music by Erik Satie and **Igor Stravinsky** (1882–1971). Having never before made a film, Man Ray objected that he didn't have any equipment to make one. Tzara suggested that he use the Rayograph technique. *Return to Reason*, a cameraless film, was projected on July 7, 1923. The screen hopped with blinding ghosts of tacks and pins, a veritable blizzard created by salt and pepper. A riot ensued and the event proved to be a Dada triumph. Man Ray got a movie camera and his subsequent films became classics of Surrealist cinema. Two examples are:

Emak-Bakia, 1927. Named for the villa where it was shot, this film juxtaposes cinematic effects (a multi-eyed lens, prismatic lighting, reverse motion, double exposures) with Surreal emblems (a woman's legs, eyes on the headlights of a car, mirrors) in a jumbled sequence of images that don't come together as a story.

Les Mystères du Château de Dé, 1929. *The Mysteries of the Castle of Dice* was commissioned by the Comte de Noailles, whose wife was thrillingly a descendent of the

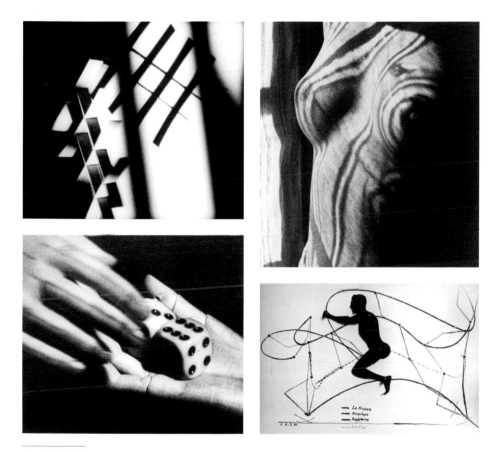

CLOCKWISE FROM TOP LEFT
Extracts from Man Ray's movies: *Return to Reason*, 1923, showing geometrical forms; *Return to Reason*, 1923, showing nude Kiki with reflection of curtain; *Emak-Bakia*, 1927, showing a businessman character/moving figure; *The Mysteries of the Castle of Dice* ("Les Mystères du Château de Dé"), 1929

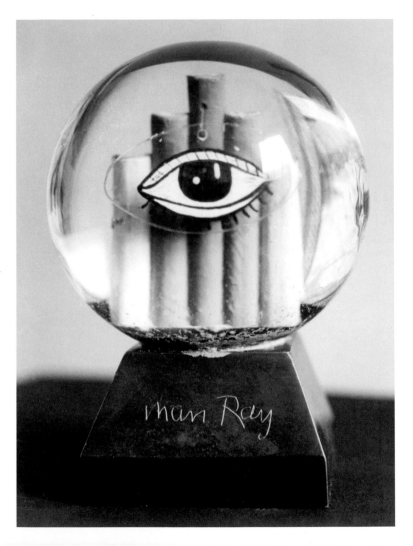

Snowball. 1927
Eye in snow
dome, with
Man Ray's
signature tubes
inside

family of the **Marquis de Sade** (1780–1814) and was filmed during a weekend party at the count's country house. The guests, with stockings over their faces, participated in all kinds of Surreal situations.

Really, Really Surreal

Man Ray's first couple of years in Paris coincided with a period of transition in the art world. Dada was on the wane—if not dead. But it was some years before the next movement, Surrealism, would evolve. Having participated in Dada's last major show, held in June 1921, Man Ray took part in the first exhibition of Surrealism which occurred in 1926. Man Ray would become the movement's official photographer:

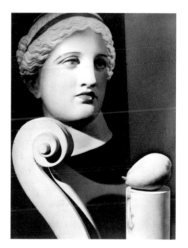

Venus Total Eclipse. c. 1930
Object consisting of a pear, a piece of furniture, and a bust of Venus de Milo

- His photographs were included in Surrealist exhibitions.

- He photographed the works of other Surrealists, and he documented Surrealist exhibitions.

- His photographs appeared as illustrations that accompanied Surrealist texts—often without captions, as if they were just found on the page, as visual equivalents to the verbal images.

- His photographs were featured in issues of the influential Surrealist magazine *La Révolution Surréaliste*.

WASTELAND ("TERRAIN VAGUE"), 1929
Gelatin silver print

What: "Wasteland" is the rare outdoor image by Man Ray. It's a street corner of the Parisian neighborhood of Montparnasse, but it doesn't look real.

Surreal: The split tree trunk, the skeletal bed, the path leading bleakly nowhere—all of this sets the stage for a bad dream.

Pruned Picture: The contact sheet for this picture shows that Man Ray carefully cropped out all the ordinary bits of scenery (the leaves on the tree, for example). He turned *someplace* into a Surrealist *no place*, simply by **framing**. In doing so, he achieves an effect that echoes the feelings in Atget's modern cityscapes: uncanny emptiness and isolation.

Personal landmark: This picture can be seen as a reflection of Man Ray's own desolate state of mind. Another work of the same year depicts thoughts of suicide: For the Surrealists, the freedom to take one's own life was the ultimate act of liberation.

Side tracks and starting over: In 1929, Man Ray decided it was time to start over with his work. This image, as a point of departure for this new phase in his career, expresses the idea that he doesn't know where he's headed. But viewers who possess the benefit of hindsight can see, in this photograph, the direction that his work would take in the 1930s.

Things to come: From this point onward, Man Ray's photos will be less about objects and odd juxtapositions, and more about atmosphere, anxiety, and instability. This locale is charged with anxiety because, even though all the elements are familiar to us, we cannot quite get our bearings. The image brilliantly evokes the anguish that people everywhere were feeling about the looming threat of World War II.

In your dreams!

Of course, the key place where such surreal things happen is in dreams. Which makes you wonder, *what was going on in the world around Man Ray and in his own life to produce such visions?* Whose lips are those? What possesses a person to call a thumbtack-studded iron a serious work of sculpture? How do you get girls to appear so pleasurably tormented? The answers to these and other mysteries are to be found in the pages of this book. *Take a look at the pictures; you'll find them strange, sexy, beautiful, bizarre, perverse, and powerful.*

OPPOSITE
Self-Portrait
1932
Bronze,
spectacles, wood,
newspaper

Surrealism in a snap

Art historians usually label Man Ray a Surrealist. **Surrealism** was the major European art movement of the 1930s and 1940s, and Man Ray was the only American to play a leading role in it. Inspired by the discovery of the unconscious mind by psychoanalyst **Sigmund Freud** (1856–1939), the Surrealists sought to make those things that are presumably hidden away there—our dreams, desires, fantasies, anxieties, and neuroses—part of common experience. *Let's see those dreams, let's*

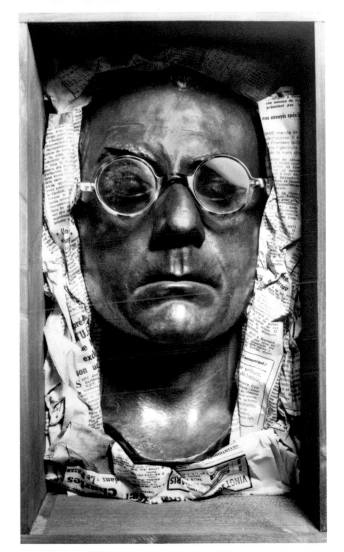

act on those desires, let's hear that nonsense, let's act bizarrely. Not only would the world be a healthier place, as implied by Freud, but it would also mean a revolution. For, in its official capacity as a movement, led by the poet and philosopher André Breton and the writer **Georges Bataille** (1897–1962), Surrealism was an attack against bourgeois values, good manners, proper behavior. Surrealism aimed to change not only art, but society at large, by freeing individuals from the constraints of conventional behavior and perceptions.

> **FYI:** *Sur* is French for "on" or "above." Surrealism is the super-reality that exists above—or on top of—the everyday reality.

OPPOSITE
Photograph-illustration made for Louis Aragon's novel, *Aurélien*
1944

Sound Byte:
With the [Surrealist] movement firmly entrenched, we met nearly every day at each other's homes or in cafés…to discuss future activities and publications. There were questionnaires on various subjects: sex, love, what was the most fatal encounter in one's life, etc. Sometimes a poet would go into a trance and write automatically, producing astonishing phrases full of anagrams and puns. Or we would simply play games, everyone participating.
— MAN RAY, describing a day in the life of a Surrealist, in *Self-Portrait*, 1963

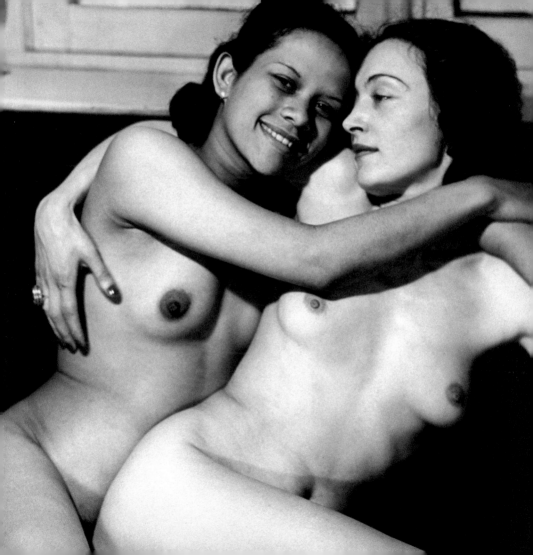

And how do Surrealists get in touch with their unconscious? You see the dilemma: A person can't just *go* there—that would be too conscious an activity. You have to sneak up on, or unleash the unconscious. The Surrealists got there by way of:

- **Dreams:** By recording their dreams, the Surrealists found rich material for visual and literary images.

- **Chance:** The Surrealists believed in the beauty of chance encounters. A favorite way of composing poetry, for example, was to draw words randomly out of a hat.

- **Play:** Games have the potential for producing all kinds of unpredictable behavior and situations; the Surrealists were especially fond of dress-ups and chess.

- **Sex:** The ultimate form of abandon. For Surrealists, images of both sexually empowered and passive women were potent keys to unlocking (male) imaginations. *For similar reasons, drugs and alcohol rated pretty highly for awakening the Surrealist unconscious.*

- **Automatism:** This was a Surrealist invention for tapping into the unconscious by writing or drawing whatever came into one's head, automatically, as if in a trance.

- **Parapraxis:** Surrealists liked to hear what was really on your mind and relished those incidents of parapraxis, those verbal blunders, those slips of the tongue, that say shockingly more than you intended. *Complimenting someone's (hideous) hat, you blurt out, "Smashing rat!"*

OPPOSITE
Ady Fidelin and
Nusch Éluard
1937

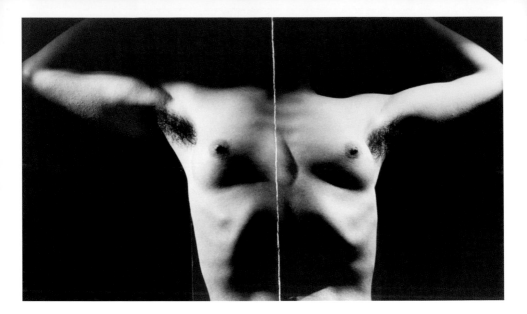

The Minotaur
1935

Convulsive or Surreal Beauty

You can imagine the Surrealists' idea of beauty was bound to be pretty weird. And it was. Traditionally, a statue, a building, or a painting is considered beautiful when its composition is symmetrical, colors are harmonious, and its expression is balanced between emotion and intellect. But the Surrealists said: *Hooey to all that. How boring.* They found beauty in beauty's opposite: in images of disembodied body parts, dangerous sensations, and disrupted forms. You might say "Gross" but, the Surrealists would sigh, "How lovely."

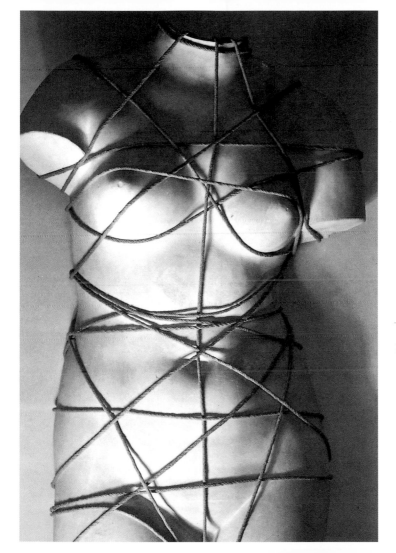

Venus Restored
1938

Surrealist Snafu

As you will see, Man Ray's beautiful pictures deploy all the strategies of successful Surrealism—including sex. When asked as an old man, "What inspired you the most?" he replied, "women." And though he was not politically involved in the Surrealist movement, he was committed to its fight to free the imagination. Man Ray was a lifelong bohemian, who never compromised himself for the sake of convention. His answer to the necktie was a shoestring, bought cheaply and worn with great personal dignity. And like a good Surrealist, Man Ray always insisted that chance did his best work for him. As history proves, this wasn't exactly the case: Man Ray worked expertly and constantly to invent new work. Chance played its part, but art worked harder!

The artist's signature

Man Ray

The Essential Mystery

Given his inventive approach to just about everything in life and art, there remains something bewildering about Man Ray's attitude toward his own work. It's a thing that stymied his career. A thing that frustrated curators and collectors. A thing that got in the way of his enjoying financial success during his own lifetime. Call it the Essential Mystery: *Why, oh why, did Man Ray spend so much energy insisting that his paintings were more important than his photographs?* As you will see, the paintings are indeed great; they relate fully to the avant-garde art of the day, but not like the photographs, which were like nothing anyone else was doing. Man Ray actually resented the success of his camera work. He felt it got in the way of people's appreciating him as a true artist. When photography curators approached him for exhibitions, he refused!

Was it because he felt painting was a purer art form? A strange attitude for someone who made photographs like paintings and sculptures out of lampshades! Was it because he didn't trust his success as a photographer? Was it because of attitudes within the art world in general?

Sound Byte:
Whatever the variations and contradictions, two motives directed my efforts: the pursuit of liberty and the pursuit of pleasure.
—MAN RAY, *Self-Portrait*, 1963

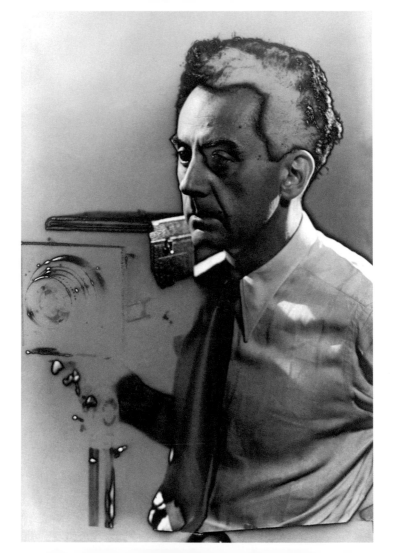

"Painting" is generally the first thing that comes to mind when someone mentions "a work of art." In fact, there was barely a market for photography until the 1970s.

In Man Ray's day, prints were simply not valued as highly as canvases. The photo world was considered separate from the art world. **And Man Ray wanted to be taken seriously.** Ironically, and largely due to his legacy, things are different now. **Cindy Sherman** (b. 1954) and **William Wegman** (b. 1943) are two of the most celebrated artists working in photography today.

Sound Byte:
It is clear from the present vantage point that precisely in professing a contempt for the photographic medium, he succeeded in making it work fluently for him.

—JANE LIVINGSTON, art historian, in
L'Amour Fou: Photography and Surrealism, 1985

FYI: Real or Fake?—The market for Man Ray's photographs is riddled with questions of authenticity. The most valuable ones are vintage prints he made himself. Because he routinely worked with assistants to create editions of prints, and frequently farmed out his old negatives to laboratories to make new duplicates, the confusion seems to be almost part of the work.

Objects of Desire

The hallmarks of Man Ray's Surrealist photography include:

- **Paradox:** Since photography is about the *real* and since Surrealism is about the *greater than real* (i.e., the mind's inner vision), Surrealist photography seems to be a contradiction in terms. This is precisely why Surrealist photography is so interesting to contemplate and, for many people, much more interesting to think about than Surrealist painting: It is photography that is *both real* and, in certain hands, <u>*sur*</u>*-real.* It intrudes upon reality.

OPPOSITE
Extract from
Man Ray's movie
Emak-Bakia
1927

- **Framing:** By carefully framing his photographs, Man Ray both documents and creates the erotic and the uncanny (i.e., the signs of Surrealism at work) as part of everyday life. *It's a matter of isolating and lavishing the attention of photography on a given subject—a ball of dust, a key—that can transform it into the surreal.*

- **Doubling:** Through the process of double exposure (i.e., by showing two versions of one subject within a single frame), Man Ray's photographs imply that things aren't necessarily as they seem. The idea of an original or true reality is only a matter of limited perspective. *To the Surrealist, the conscious world always had its equivalent, or double, in the unconscious world.* (This may also explain why Man Ray reproduced his own work—both the photographs and the objects—so freely throughout his life: *Why impose any limits or rules on oneself?*)

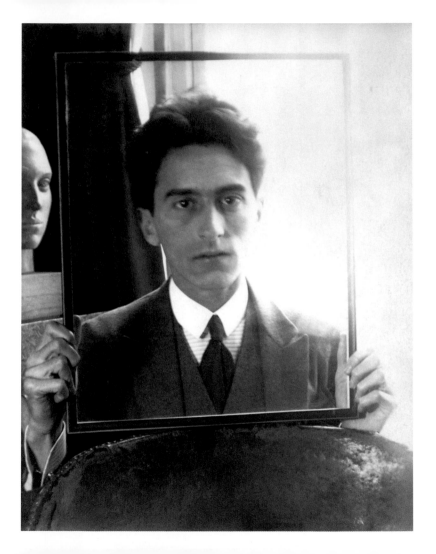

- **Fetishism:** A fetish is an object or image imbued with such intense erotic power that fondling it (with your hands or your eyes) can **replace the act of sex** itself. Gloves, shoes, dolls, and mannequins are classic Surrealist fetishes. Look for these images in Man Ray's pictures and in his fashion photography. The photographs themselves represented a kind of fetish for Man Ray and his friends, as we see in the photograph of Jean Cocteau on page 88. Snapped to contain the Surrealist imagination, these photographs were powerful objects of desire.

OPPOSITE
Portrait of
Jean Cocteau
holding a frame
in front of his
face. 1922

Sound Byte:

> *My reaction to the hectic Twenties began in 1929.*
> *I decided to start all over again.*
> —MAN RAY, *Self-Portrait*, 1963

Lady Lee

Man Ray had a rough year in 1929. Kiki had left him. The stock market crash left him financially uncertain (he had been saving his money in an American bank all these years). Anti-American feelings were on the rise in Europe. He made strange, powerful images of **wasteland** and **suicide.** But just as things were looking grim, enter Lee Miller, a blonde American beauty, who arrived in Paris determined to

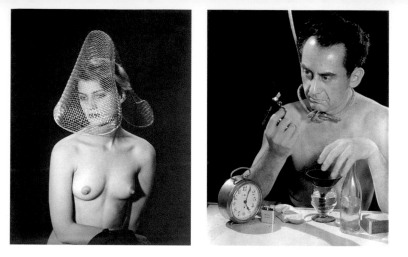

study with Man Ray. When he told her *"I don't take students and I'm about to leave on holiday,"* she responded, *"Fine, I'll go, too."* Thus began an intense and torrid affair: man and woman, teacher and student, artist and model. It evolved quickly (with the pupil) into a bitter rivalry between two talented artists. Lee soon left to open her own portrait studio in New York, and in 1934 she married an Egyptian and moved to Cairo.

FYI: The amazing Lee Miller became a war correspondent for *Vogue* and was one of the first to photograph the liberated victims of the concentration camps in Germany. In 1947, she resumed her friendship with Man Ray and married **Sir Roland Penrose** (1900–1984), the Surrealist artist and collector. She lived out her days as **Lady Lee.**

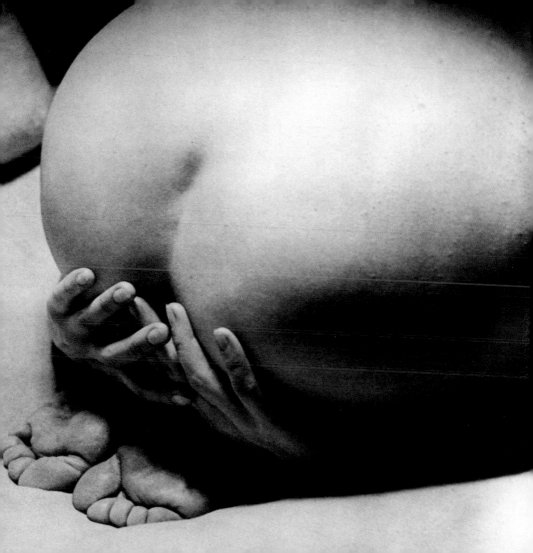

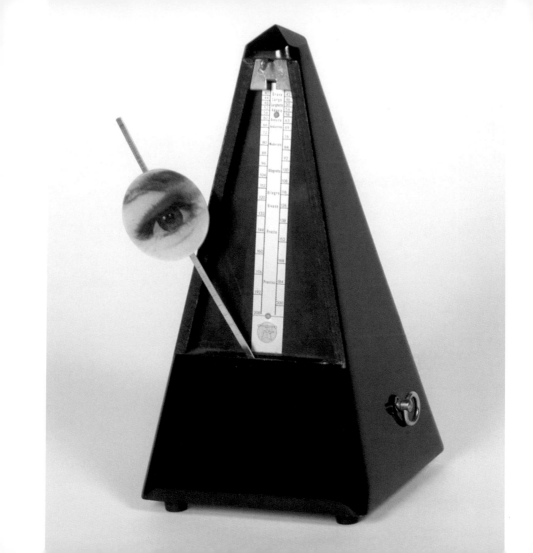

Lips and Ass

Lee Miller inspired some of Man Ray's most erotic and sadistic works of art. The artist enjoyed telling how they *chanced* upon the sexy-looking solarization technique together in the darkroom. Her appearance coincided with the introduction of themes of sadomasochism in Man Ray's images: spankings, bondage, and lusciously tender flesh. These themes were also prompted, in part, by Man Ray's meeting **William Seabrook** (1886–1945), a writer obsessed with kinky sex, for whose wife the artist designed a "painful" silver collar. After Lee left him, Man Ray expressed his frustration through images of her that spoke of tormented desire:

OPPOSITE
The Object to Be Destroyed ("Objet Indestructible"). The original metronome, named *Indestructible Object*, was created in 1923 and had an anonymous eye. After Lee Miller left him, Man Ray replaced the eye with a photograph of Lee Miller's eye, and renamed the work *The Object to Be Destroyed*

- *The Object to Be Destroyed.* He revamped this object of 1923, a musician's metronome, by attaching a cut-out photograph of Lee's eye to the needle. One sees on the back of the object instructions to go ahead and smash the thing. *After the work was destroyed by some students at a 1957 exhibition, Man Ray decided not to press charges: They were only doing as told—though it would have been preferable had they used their imaginations, not a hammer!*

- *Monument à D.A.F. de Sade*, 1933. Superimposed on top of a photograph of a woman's buttocks, Man Ray has outlined an upside-down cross; when you rotate the picture, the crucifix becomes a phallus. Man Ray, like the rest of the Surrealists, idolized the Marquis de Sade, who made a religion of pornographic sex, which

he considered the ultimate act of freedom—*even when it involved making servile objects of women.* The photograph was so closely cropped, that the woman's flesh came right to the edges.

- ***The Lovers***, 1932–34. Inspired by a memory of Kiki's lipstick on his collar, Man Ray devoted two years to making a highly precise blow-up of a photograph of Lee's lips floating in the sky, over the observatory near the studio where they lived together. (You can see this photograph on the end pages at the beginning and end of this book, inside the book jacket.)

OPPOSITE
The Kiss ("Le Baiser"). 1930
Lee Miller and Belbourne

BELOW LEFT TO RIGHT
Variations of Man Ray's *White and Black* ("Blanc et noir") bondage photographs
1928–29

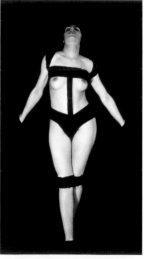
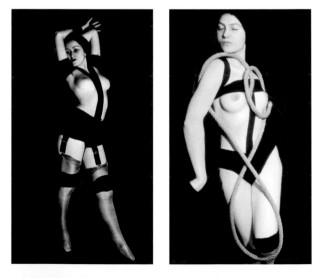

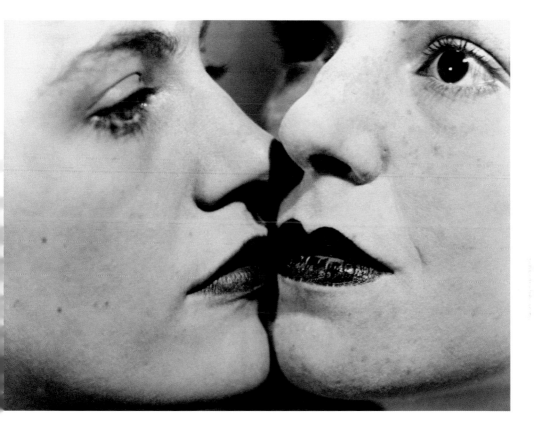

afin que.... les traces de ma tombe disparaissent de dessus de la surface de la terre, comme je me flatte que ma mémoire s'effacera de l'esprit des hommes... D.A.F. SADE.

Surrealist Triumphant Returns to Painting

Man Ray was briefly in New York for the 1936 Fantastic Art, Dada, and Surrealism exhibition at the Museum of Modern Art, where his painting of Lee's lips was a star work. Never mind that the catalogue cover featured a rayograph. Concurrent with the show, Man Ray published in Paris a portfolio of photographs perversely titled, *Photography Is Not Art, Art Is Not Photography*. This was followed in 1937 with a portfolio of dream-inspired drawings, *Free Hands* ("Les Mains libres"), which as good as sealed the deal: ***From then on, Man Ray's commitment as an artist would be to Surrealist painting.*** Its hallmarks are:

- **Dream Images:** Like all good Surrealists, Man Ray kept a bedside journal to record his dreams. This served as a menu of ideas for images for his work.

- **The "Where Am I?" feeling:** These works are stocked by weird characters (mechanical-looking figures), situations (strange perspectives, fantastic structures), and symbolic relationships (numbers, geometry, algebra).

- **Un-painterly painting:** *Making* pictures has replaced *taking* snapshots. He may have turned his back on photography, but he still wanted his work to look as if it made itself, or at least that it didn't depend on traditional studio labor. In creating these works he drew on his expertise as a draftsman and illustrator, and frequently painted from photographs.

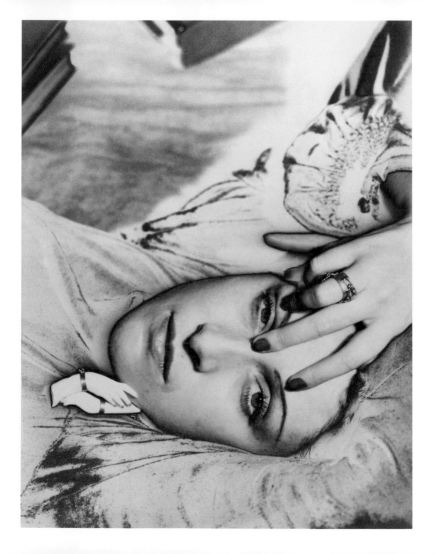

SOLARIZATION

What: A photographic technique that produces unpredictable reversals of tone: *burning* an image black and *blazing* it with light.

How: Solarization occurs when a partially developed negative or print is charged with a pulse of light and is thus exposed. It's an erotic white heat that makes even the most mundane flowers appear unreal, surreal, sexual, dead—as though handed to you from inside a dream.

Man Ray's version: He tells a story of being in the darkroom in 1929 with his new assistant, Lee Miller, when a *mouse* runs over her foot. She screams and accidentally switches on the light. Instead of ruining the prints they are developing, *he* discovers that the "accident" created this amazing effect. In Miller's version of the story, she took sole credit.

History's version: Solarization is a very old photographic technique, first discovered by **Armand Sabbatier** (1834–1910) in 1862. It is also called the Sabbatier Effect.

Whatever you call it: The technique is the most important innovation of Man Ray's work of the 1930s.

ABOVE
Lilies. 1930
Solarization

OPPOSITE
Portrait of Dora Maar. 1936. Solarization
(Maar was a photographer and lover of Pablo Picasso, who immortalized her in his painting *Weeping Woman*.)

Exodus

Man Ray spent the summer of 1937 in Cannes with his girlfriend, a dancer from Guadalupe, the exotic **Adrienne "Ady" Fidelin** (c. 1886–?) and three other artist couples, including Picasso and his lover Dora Maar. It was an idyllic holiday—save the imminence of war. Back in Paris for an international exhibition of Surrealism, to be held in the beginning of 1938, Duchamp masterminded the idea that artists would dress (or undress) a group of store mannequins and that Man Ray, who would take charge of the lighting, would hand out flashlights.

In the spring of that year, Man Ray painted *Beautiful Weather*, a nightmare image of alien male and female figures divided by a bleeding door, beasts in a death clinch, and barren trees. Meaning: German troops were approaching. *It was time to get out of France*, but Man Ray dreaded the idea of leaving. He waited until the last possible moment to join the hordes heading south, where he eventually boarded a ship—the same one that his fellow Surrealist **Salvador Dalí** (1904–1989) happened to be on. During the crossing, most of Man Ray's camera equipment was stolen.

ABOVE
Man Ray mannequin at the *Exposition internationale du Surréalisme*. 1938

OPPOSITE
Beautiful Weather ("Le Beau Temps") 1939. Oil on canvas

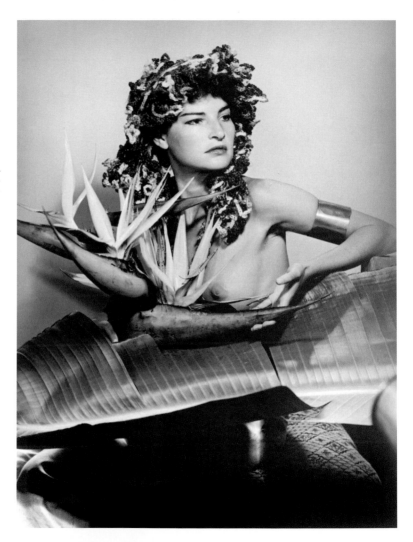

Juliet Browner
c. 1945

California is a beautiful prison. I like being here, but I cannot forget my previous life, and I long for the day when I can return to New York and eventually to France.

—MAN RAY, in a letter to his sister from Hollywood, 1948

Beautiful Prison: 1940–51

Man Ray arrived in America on August 16, 1940. After visiting briefly with his family, he put as much distance between himself and New York as he could. Having just turned 50, he hit the West Coast in October, with no other choice but to start life afresh. He figured that, given his reputation in film, photography, and fashion, Hollywood would be his best bet. Unfortunately, there wasn't much call for Surrealist talent and he scored only one commission: to paint a portrait of actress **Ava Gardner** (1922–1990) for a movie prop. Professionally, it was going to be a rough ten years. Personally, love was in the air!

Juliet

On his first day in Los Angeles, Man Ray met **Juliet Browner** (b. 1912), a shy, beautiful, free-spirited 28-year-old transplant and modern dancer from the Bronx. *You guessed it:* Man Ray fell in love. They moved in together, and, on October 24, 1946, got married. Juliet was to be his muse, model, and loving partner for the rest of his life.

Career and Chess Moves

During the 1940s, while living in California, Man Ray began to gain recognition as an artist. There were solo museum exhibitions of his past work, lectures to growing audiences of young artists, and two gallery exhibitions of his new work:

- *Objects of My Affection*: a group of small constructed objects (read fetishes) with chatty titles. Shown in New York City in 1945 at the **Julien Levy Gallery**, Surrealism's American headquarters. Man Ray's old pal Duchamp designed the brochure.

- *Shakespeare Equivalents*: a series of paintings based on photographs taken in Paris of mathematical models. These works argued Man Ray's view that abstraction was the modern artist's way of solving

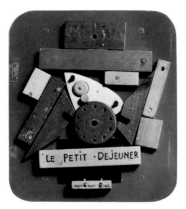

ABOVE
Breakfast ("Le Petit Déjeuner"). 1945

OPPOSITE TOP
*Painting "King Lear":
Shakespearean Equivalents*
series. 1948

OPPOSITE BOTTOM
Chess Set

FYI: Remember the **Arensbergs,** from Man Ray's Dada days in New York? They were now living in L.A., where Walter was trying to prove that Francis Bacon was Shakespeare in disguise. Man Ray's **Shakespeare Equivalents,** each titled after one of the Bard's plays, may facetiously refer to Walt's obsession.

"the human equation." The images were shown in 1948 at the artist-entrepreneur **William Copley**'s (1919–1996) short-lived L.A. gallery.

But the art did not sell. Man Ray supported himself, in part, by designing sculptural **chess boards,** which he sold in limited editions. *So what was the big deal with chess all these years?* Think about it: a **game** of **strategy** and **chance**, with sexy-sounding **moves**, like "Queen takes Knight"… *Surrealist rapture!*

LA RUE FÉROU, 1952
Oil on canvas: 31 ½ x 23 ½" (80 x 59.7 cm)

What: A view of the street where Man Ray and his wife Juliet settled in 1950, upon his return to Paris after 11 years absence, and where he would remain for the last 26 years of his life.

The painting: Ever the contrarian, to the end Man Ray claimed that he painted this picture *even though he could have photographed it.* Indeed, compared with many of his other, more experimental Surrealist paintings, this one is relatively realistic. (References to the famous Surrealist painters de Chirico and Magritte ring loud and clear.) *Except for that strange something in the street.*

Mysterious Object: *What is that thing on the back of the cart that the man is pulling up the street?* Why, it's *The Enigma of Isidore Ducasse,* one of Man Ray's quintessential Dada objects of 1920. (See pages 36–37.)

Mindscape: In his later years, Man Ray made replicas of many of his early works. In light of this, *La Rue Férou* can be seen as an intimate landscape—a picture of an artist's imagination filled with images of its own making.

Return of the non-Native: 1950–76

The war ended in 1945, but it was not until 1950 that Man Ray returned to his beloved Paris. Juliet was reluctant, since she did not speak French and she hated to be cold. They arrived in spring and moved into an unheated former garage on the **rue Férou**. Here's what was amazing: Man Ray was a 60-year-old, financially insecure, creatively restless bohemian raring to start all over again. It would take a lot of work to make the garage livable, and, despite the furnishings that Man Ray rigged up, the place was never really warm. The couple began a sweet ritual of enjoying croissants and coffee (and recording dreams) in a long morning of keeping warm in bed. (*Shades of rustic Ridgefield in downtown Paris!*) Visitors were struck by the elegant poverty of the place, packed with Man Ray's art and treasures, all precisely arranged. It was like walking into a collage. Even though he lacked luxuries, Man Ray still relished his freedom.

LEFT AND RIGHT
Examples of
Man Ray's
Natural Paintings
1958–59
Acrylic on canvas

Ever Experimental

Man Ray slowed down, but he never quit. During the 1960s, he made some wonderfully experimental and playful works:

- *Ma Bête Noire et Ma Boîte Noire—A pair of Natural Paintings* (1965), is a pun on "my pet peeve" (*ma bête noire*) and "my black box" (*ma boîte noire*); the "Natural Painting" was made by squishing paint between two boxes. (See images on page 107.)

- *Self-Portrait* ("Pain peint") is a loaf of painted French bread; the title, when spoken aloud, sounds like the fire-engine sirens in France.

Autobiography

Critically speaking, people seemed more interested in Man Ray's photography than in his painting, which annoyed him. To set the record straight he published his autobiography, **Self Portrait,** in 1963. It was a funny, anecdotal, and at times disturbingly honest account of a life committed to personal freedom. *Read it!* But be prepared, Man Ray's treatment of dates and histories is *mysterious* at best. Over the years, he also made new editions of his early objects. Man Ray never

earned a lot of money, but there were increasingly steady sales and some major retrospective exhibitions, including the one in 1966 at the L.A. County Museum.

End Notes

Man Ray outlived such dear friends as Marcel Duchamp, who died in 1968. He enjoyed good health—except for a bum knee that had him walking on two canes. (If you offered to give him a hand, he would give you a spunky snarl.) On August 27, 1976, he celebrated his 86th birthday and was honored by the French government for his artistic achievement. Less than three months later, on November 18, Juliet was awakened by the sound of his struggling for breath. He died within

LEFT
Trompe l'Oeuf ("Fool the Egg," a pun on *Trompe l'Oeil*, "Fool the Eye")
1930

RIGHT
Catherine Deneuve with lampshade
1966

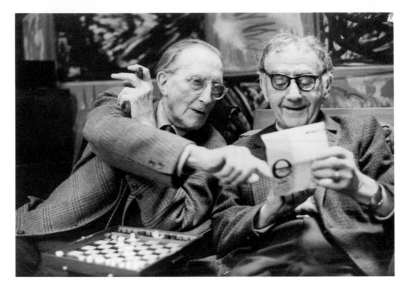

hours and she couldn't bring herself to cry for a year, so profound were her sorrow and shock. Since Man Ray didn't care for ceremony, he was buried, respectfully, with as little decorum as possible in the Cimetière du Montparnasse in Paris in an unmarked grave. A simple wooden marker was later added, indicating his name, age, and year of death: Man Ray—86 ans—1976.

Summing Up a Man and his Mystery

The American-born artist Man Ray lived and worked during the better part of his life in Paris. When he was a boy in Brooklyn, his early

talent for illustration promised an architectural career, but Man Ray decided to take the less charted path by becoming an artist. He spent his early adult years as a painter absorbing the lessons of European Modernism in New York while also living on a commune in New Jersey. His friendship with the French avant-garde artist Marcel Duchamp turned the key that unlocked the door to his own artistic future. From 1916 to 1921, the two men were at the heart of the New York Dada movement, expressing their strangely detached fascination with images of machinery overtaking humankind. While he was a Dadaist, Man Ray began making photographs, a medium that would earn him commercial success and artistic recognition. In 1921, seeking a more supportive context for his work—and fed up with Manhattan—Man Ray moved to Paris, the international epicenter of Modern culture, where he played a leading role in the Surrealist movement. In 1940, with the outbreak of World War II, he returned reluctantly to America, where he renewed his commitment to painting. He bided his time in Hollywood until he could return to Paris, which he did in 1950. He died there in 1976.

Three Essentials to Understanding Man Ray

- **Freedom:** Man Ray's heroes—from Alfred Stieglitz to the Marquis de Sade—were emblematic of the sense of personal freedom he prized above all conventional notions of success.

- **Invention:** He never settled into a single way of working. He moved endlessly between photography, object making, painting, drawing, and writing poetry. Within a given medium, he was always looking for new possibilities, and created for himself his own variations of the aerograph, the rayograph, and solarization.

- **Mystery:** Man Ray insisted on attributing his achievements to chance, rather than to hard work or even to a sense of photographic history. Like a good Surrealist, he wanted the impact of the image—without any boring questions about the artist or his technique—to command the imagination into experiencing extraordinary pleasures, such as ecstasy, delirium, beauty, enigma, and mystery.

So what about the essential mystery?

Why did he so adamantly insist on being recognized as a painter and not as a photographer? Well, judging from those three essentials and the fact that he spent his entire life making works of art that were nothing if not mysterious, troubling, and/or funny, the answer seems clear: Ultimately, Man Ray never wanted to accept a given answer or to arrive at a fixed conclusion. He wanted his art to keep both himself and us guessing.

À L'HEURE DE